The Scottish National Portrait Gallery
21 August to 21 September

Painting in Scotland 1570-1650

Duncan Thomson

Edinburgh
The Trustees of the National Galleries of Scotland 1975

Contents

Foreword

Since 1951 the Scottish National Portrait Gallery has held a series of annual exhibitions illustrating aspects of Scottish history. These started in that year with *Scottish Literary Personalities of the Eighteenth Century*. The others have included *Renaissance Decorative Arts in Scotland 1480–1650* (1959), *Sport in Scotland* (1962), *Scots in Italy in the Eighteenth Century* (1966) and *A Virtuous and Noble Education* (1971). The series now continues with the present exhibition, which is intended to provide a definitive account of the early history of painting in Scotland.

We could not have covered this subject fully without the help of many owners, both private and public. Their response to our requests for the loan of their pictures has been extremely generous, and I should like to express to all of them the thanks of the Trustees, the staff of the Portrait Gallery, and myself. We are particularly grateful to Her Majesty The Queen for her gracious permission to include the *Darnley Memorial* painting from Holyroodhouse. The ceiling formerly in Rossend Castle perhaps also calls for special mention. Our thanks are due both to the Trustees and Keeper of the National Museum of Antiquities of Scotland for agreeing to lend the ceiling, and to the staff of the Department of the Environment who have installed it in the exhibition.

The exhibition and the catalogue are the work of Dr Duncan Thomson, Assistant Keeper in the Portrait Gallery.

HUGH SCRUTTON
Director
National Galleries of Scotland

Preface

When the idea of the present exhibition began to take shape, it was envisaged that it would take the form of an investigation of the origins of Scottish painting. It became clear, however, that there was so little surviving material evidence earlier than the last few decades of the sixteenth century that a coherent picture could be formed only by starting at what might seem a rather arbitrary point, which is, nevertheless, the point where evidence that is not purely documentary becomes sufficiently plentiful to be able to detect certain cohesive themes at work within the history of painting in Scotland, and where it becomes possible to relate it to external influences and to the historical and social development of the times. An investigation of 'origins' might also imply the making of quite wide comparisons within the field of English and European painting which space considerations alone would have made impossible. It is hoped, however, that such questions have not been lost sight of in the catalogue. The exhibition is thus an attempt to trace the development of painting in Scotland from broadly the time of the childhood of James VI and I to the end of the reign of his son Charles I.

To give a proper balance to the painting of the period it was always obvious that a good deal of emphasis would require to be placed on the work of the decorative painters, but a difficulty here was that most of their surviving work was still *in situ*. Fortunately, it has been possible to include an entire painted ceiling formerly in Rossend Castle and for this perhaps unique opportunity I am most grateful to the National Museum of Antiquities of Scotland and its Keeper, Mr R. B. K. Stevenson. For the successful installation, a very great debt is due to the officials of the Department of the Environment: Mr P. H. Ogle-Skan, Director of Scottish Services of the Property Services Agency, Mr R. H. H. Forster, Area Works Officer, and Mr J. M. Christie. The restoration has been supervised by Mr Rab Snowden of the Stenhouse Conservation Centre and I am very grateful indeed for his interest in the project.

While some aspects of the exhibition are necessarily speculative, it is hoped that the juxtaposition of so many of the obviously important paintings of the period will help to clarify some of the outstanding problems. This aim has been made a great deal easier to achieve by the efforts of Mr John Dick, Restorer for the National Galleries of Scotland, who has cleaned and restored eighteen of the pictures included in the exhibition. I am very grateful to him for this work, for revealing discussions on the status of many of the pictures, and for his sensitivity towards the historical problems involved. Some of this work was incomplete when the catalogue went to press, and a few of the illustrations are, therefore, necessarily from photographs taken before cleaning. There may also, as a result, be some discrepancies between a particular catalogue entry and the painting as exhibited. I also owe a considerable debt to my colleague Mr R. E. Hutchison, Keeper of the Portrait Gallery, who has given help and encouragement. Miss Sheila Bruce Lockhart has given me valuable assistance, and Miss Christine Haddow has produced an immaculate typescript of the catalogue. I am grateful to Mr R. Burnett of the Stationery Office for the care he has taken in the design of the catalogue.

I must also add my thanks to those of my Director to the many lenders to the exhibition. I am particularly grateful for the opportunities they have given me to examine pictures in their collections. I would also like to express my thanks to the following: Dr Michael Apted of the Inspectorate for Ancient Monuments; Dr R. Donaldson of the National Library of Scotland; Mr Evelyn Joll and Mr W. G. Plomer of Thomas Agnew & Sons; Mr J. T. Kelman and Miss J. M. Black of the University of Aberdeen; Mr David Learmont of the National Trust for Scotland; Mr I. H. J. Lyster of the Royal Scottish Museum; Mr R. O. MacKenna and Mr J. Baldwin of the Library of the University of Glasgow; Mr Stuart Maxwell, Mr Charles Burnett, and Mr David Caldwell of the National Museum of Antiquities; Mr A. D. Reid of Newbattle Abbey College; Dr A. J. Rowan of the University of Edinburgh; Mr Tom Scott; Major R. Smith.

DUNCAN THOMSON

Introduction

On 5 May 1579, Archibald Douglas, kinsman of the recently deposed regent the Earl of Morton and later to be tried for his part in the murder of Lord Darnley, wrote from Stirling to Sir George Bowes, who had charge of the garrison at Berwick, concerning a portrait of the king by a Flemish painter whom he did not name. The painter, he reports, had been driven out of Stirling but he is now attempting to gain him permission 'to se the King's presence thrise in the daie, till the end of hys worke'. Almost a month later, on 3 June, he reported that the king's portrait 'according to his proporcon in all parts' had been completed, though it had 'been so longe in makinge, and so difficult in getting' that he was 'allmost weryed therewith'.[1] This letter introduces a variety of themes which have a greater or lesser effect on the course of the history of painting in Scotland during the last four decades of the sixteenth century.

The first and most obvious of these themes is the turmoil which existed in the country during the minority of the king as a variety of factions intrigued, succeeded one another, and fought for control of the king's person. The fate of his exiled mother, Mary, Queen of Scots, would not finally be decided until 1587, in which year James himself came of age and finally broke free from those who too closely surrounded him. In the immediate aftermath of the queen's abdication, the struggle between Marians and a king's party led to the killing of the first two regents, Moray in 1570 and Lennox the following year. Civil war continued until 1573, when a kind of order was established by the victory of protestant, pro-English forces, with help at last from Queen Elizabeth who had finally concluded that support for the king's party and order in Scotland best served her own ends. Effective power lay with James Douglas, Earl of Morton, who had succeeded Mar as regent in 1572, though he never received the whole-hearted support from Elizabeth that his policy perhaps deserved.

Morton's position had already slipped irretrievably when his kinsman wrote the letters quoted above—the second letter goes on to request a messenger to carry the portrait to London where Robert Bowes, Sir George's brother and Elizabeth's Scottish ambassador, will present it to the queen, a tiny link in that chain of events which was to lead to James's accession to the English throne. During 1578 the custody of the king passed back and forth between Morton and his opponents, a struggle which must have been responsible for the long delay in completing the portrait in question. By September 1579 the young king's affections had been captured by his father's cousin, Esmé Stewart, soon to be created Duke of Lennox, who became a focus for Morton's opponents. On the last day of 1580 Morton was arrested for his part in Darnley's murder and was executed the following year, despite half-hearted attempts by Elizabeth to prevent it. Thus, the cry for revenge which had been enshrined in the *Darnley Memorial* (no. 1) more than a decade earlier by the regent Lennox was still effective. This issue remained alive until the year before Mary's execution when the writer of the letters was tried for the same crime, but acquitted.

The theme continues unabated into the 1580s, no administration, no interest remaining in power for long, personal feuds cutting into political alignments, the king always liable to be caught up in a game he could not control. The Duke of Lennox appeared to represent a shift towards the catholic, French, or Marian interest and this was countered by the 'Ruthven raiders' led by the Earl of Gowrie, representing the extreme protestant reaction, who seized the king in 1582. Though this party inclined towards England, Elizabeth soon toyed with the idea of returning Mary to Scotland to reign in association with her son, a move which would be in keeping with her alliance with France and would perhaps weaken pro-Spanish influences in Scotland—for Spain was the immediate enemy. Such were the intricacies of policy that when the Earl of

[1] *Memorials of the Rebellion of 1569* [edited Sir Cuthbert Sharp], 1840, p. 392. References are not given in the Introduction if the material occurs in the Catalogue section, where a full reference will be found.

Arran supplanted the Ruthven party with the help of the northern conservative nobility (Gowrie was executed in 1584), the extremists among Elizabeth's advisers, but not Elizabeth herself, saw this as a move towards the rehabilitation of Mary.

After further trouble at Stirling Castle in April 1584, Arran strengthened his position and the presbyterian leaders fled to England. Arran's administration was moderate, rather like Morton's, but he in turn was undermined mainly through the influence of the Master of Gray and Maitland of Thirlestane, and by the return of the exiled lords, Mar, Glamis, and Angus, who attacked Stirling in November 1585.

In quick succession followed a series of events which in a sense simplified the situation: in 1586 a league for mutual defence was formed between Scotland and England with Elizabeth giving a little ground on James's right to succeed her; then came the removal of Mary from the scene, an event which the same Archibald Douglas, who now represented the king in London, implied would not unduly upset James if his rights should receive recognition; and, finally, in 1588 the Spanish danger disappeared with the loss of the armada.

In his final Scottish years the king, who now had personal power though he was never quite free of the fear of abduction or assassination, sought to reconcile the opposing factions within his realm and he was increasingly successful. Irrational feuding continued among the leading families and the so-called 'Roman catholic' interest remained active in the north, principally in the person of Huntly who was personally favoured by the king. Despite his involvement with Spanish interests and his slaughter of the Earl of Moray (see no. 25), little effective action was taken against him. On the other side, the protestant Francis Stewart, Earl of Bothwell made two nearly successful attempts to seize the king in 1592 and 1594 before leaving the country in the following year. Ultimately, action was taken against Huntly who was forced abroad in the same year, though he returned in 1596 and with Erroll was accepted by the church. The king now steered a course with some assurance between extremes, a course now set fair for accession to the English throne.[1]

A second theme which is heard in Archibald Douglas's two letters is the difficult course which the arts must follow against such a background of strife, unrest, and (as a consequence) an ever-increasing deficit in the treasury. Painters of any degree of sophistication were rare and inevitably foreign, and such were the rewards and such the limited demand that they were hardly likely to be of the greatest accomplishment. In such records of them as exist, their names being strange are often omitted—a French painter at the court in 1573, the Flemish painter in Douglas's letter of 1579, 'Lord Seton's painter' in the Treasurer's Accounts in 1582 (see nos. 21 and 23). Native painters certainly existed in quite large numbers but none of their surviving work suggests any first-hand knowledge of the continental traditions of painting, and their activities were very largely confined to the decoration of ceilings and walls and heraldic and associated types of painting.

Easel-painting meant almost exclusively the portrait, which often had the very practical purpose of carrying a likeness to a recipient who, like Queen Elizabeth, might never see the subject in any other form. The portrait thus had to conform to certain external standards, necessarily those of the larger kingdom to the south, and so to those of the courts of northern Europe. The king in later life is known to have greatly disliked sitting for his portrait and this too is perhaps implied in the letter from Douglas to Bowes. His interests were literary rather than visual and this no doubt contributed to the un-adventurousness of his patronage of painters. But the dynastic significance of his own image must have been clear to him and it is possible to trace his likeness through a variety of works which appear to derive directly or indirectly from the 'King's presence'. These include the small panel of the king holding

[1] For a full analysis of the general history of the period see Gordon Donaldson, *Scotland: James V to James VII*, 1965, pp. 157–96.

a hawk (no. 8), the wood-engraving from Beza's *Icones* of 1580 (no. 10), the painting as a beardless young man of 1586 just prior to his break from those who controlled him (no. 12), a portrait of the mature and bearded king of 1595 which may have become a standard image (nos. 14–15), and a variety of coins and engravings between 1575 and 1603 (nos. 18–22).

Though so many of the records of the period, like Douglas's two letters, are imprecise, it is now possible to define something of the artistic personalities of two Netherlandish painters who were active at the Scottish court, Arnold Bronckorst and Adrian Vanson. When exactly Bronckorst first came to Scotland remains something of a mystery and an estimate of this must depend to some extent on the likely date of the portrait of James with a hawk—it is not impossible that this is the painting referred to by Douglas, though 'according to his proporcon in all parts' might seem to suggest a full-length (see no. 8). This portrait and one of the regent Morton (no. 9), with whom Bronckorst certainly had contacts, are attributed to him on the basis of a comparison with a signed portrait of Lord St John of Bletso painted in England in 1578 (no. 7). Some other paintings of the period, including one of Arran which is dated 1578 (Scottish National Portrait Gallery), may be by him, but many must have disappeared. His manner is sensitive but unadventurous, international in the sense that it derives from Anthonis Mor, but not without provincial hesitations.

A portrait in the same mould is that of George, 5th Lord Seton which appears to have been painted in the 1570s (no. 23). It is possible, though it is certainly not proved, that it was Lord Seton who introduced to Scotland the painter who succeeded Bronckorst at court after the latter had returned to London at some time in 1583. Adrian Vanson was granted the office of painter in May of the following year. He had, however, been in the country before this date, having been paid by the treasurer in 1581 for two portraits which were sent to the reformer Beza in Geneva. These are assumed to be the patterns for the engravings published by Beza in his *Icones* (nos. 10–11) which are thus the very shaky foundation on which a reconstruction of his *œuvre* must rest; unlike the case with Bronckorst, no signed picture has come to light. It is, therefore, necessary to approach Vanson in a very speculative fashion, but he was certainly the leading painter at court until 1601, in which year he painted a now vanished miniature of the king, and it seems probable that the royal portraits of the period are by him (see nos. 12, 14–16). That his name might credibly be linked with Lord Seton (see nos. 20–1) is given some support by the fact that Seton's grandson, Lord Winton, was to patronize a painter in the 1620s, Adam de Colone, who has been identified as Vanson's son.

A commentary on the economic situation prevailing in Scotland during these years is provided by the apparent cessation of Vanson's fee after November 1586 and the difficulties his widow Susanna de Colone experienced in recovering what she considered due to her late husband, an effort which continued long after James had left Scotland, and which was probably unsuccessful.

Working for the court at the same time as Vanson were three native decorative painters, Walter Binning, and James and John Workman. What is known of Binning's earlier activities, which stretch back as far as 1540,[1] do not suggest that he was likely to tackle portraiture, but with the two others it is perhaps more likely. Most of their recorded work, however, was armorial in nature and a good deal of this was concerned with the ceremonies of forfeiture: arms of the rebels would be made and painted and then subsequently destroyed at the Tolbooth and the Cross of Edinburgh—a curious form of iconoclasm in which the artist was a willing participant. James Workman was paid for such work in June 1594, the rebels presumably being Huntly and Erroll, whom the king forced abroad the following year. The same painter was active in company with John Anderson (q.v.) in Edinburgh Castle in 1617

[1] In February 1540 he was paid for painting artillery and related equipment in Edinburgh Castle (*Accounts of the Lord High Treasurer of Scotland*, vol. vii, 1907, p. 348).

when it was being prepared for the reception of the king on his only return visit to his northern kingdom, the work again mainly heraldic. There are, however, some grounds for connecting him with the tempera decorations of the emblematic ceiling at Rossend Castle in Burntisland which may be of about the same date (see no. 35).

John Workman's name is linked with the funeral ceremony of the murdered 'bonnie Earl' of Moray in 1592 but, as is so often the case, the remaining documents fail to confirm whether or not he actually painted the great and horrifying vengeance painting (no. 25). He painted banners at court and was given a monopoly to paint the arms of the nobility on their elevation, which no doubt encouraged him to describe himself in his testament as 'painter to his Majesty'. In May 1603 he painted the newly repaired coach in which Anne of Denmark set off for England to rejoin the king.[1]

The king's accession to the English throne was the central event in his life and marked the fulfilment of his policies in Scotland. It had, however, harmful effects on the immediate development of painting in the northern kingdom. There were indications that some of the decorative painters were turning to portraiture. The portrait of Prince Henry for instance (no. 26) is certainly not part of the Netherlandish tradition. Vanson had become a free burgess of Edinburgh in 1585 on the understanding that he would instruct apprentices, which suggests that the painting being done at court was beginning to have a wider influence and that demand was increasing. Anne had much greater sensitivity to the visual arts than the king, while Prince Henry in his brief life was to become an important patron: Charles, the future king, became the most discerning and influential of collectors in Britain in the seventeenth century. But the possibilities inherent in these facts came to nothing with the departure of the court and the next two decades seem bleak and empty.

Nevertheless, the decorative painters were, the surviving evidence suggests, especially active in these years, covering the ceilings of halls and long-galleries with strapwork and floral patterns, arabesques, and figural imagery drawn from classical or Christian sources.[2] Striking floral patterns are found in Northfield House at Prestonpans, New Testament scenes appear in Provost Skene's House in Aberdeen, classical imagery appears at Cullen House in Banffshire, there are moralizing emblems at Culross—pictorial and verbal rather than symbolic as at Rossend (no. 35)—while at the Dean in Edinburgh, Old Testament imagery appeared side by side with a set of personifications of the senses, subject matter which often had erotic undertones (nos. 40–6). The style is crude, rarely delicate, colour is bright but, since the medium was tempera on wood, lacking in density. The total impression, especially where the imagery is figural, is of rather misguided copying of sources not always clearly understood, nor is there ever very much evidence of an original mind creating a programme of any intellectual depth. But the best of this type of painting has a bucolic freshness, a simple spontaneity, a sense for organizing colour and shape, a gaiety, which must have been refreshing in gloomy interiors and remains so.

The patrons for this kind of work represented a wide part of the social spectrum, ranging from merchants to the great magnates, from 'new men' like Sir William Nisbet of Dean to national establishment figures like Huntly. Most of the painting tends to be found towards the east coast and there were clearly large groups of decorative painters, if not 'schools', in Edinburgh and Aberdeen. It was from this background that George Jamesone, the outstanding painter in Scotland in the second quarter of the seventeenth century, was to emerge and it is among these painters that the authors of the few outstanding portraits of the two decades in question should be sought. Traces of influence from the court style of the previous century must have remained, and certainly in a portrait like that of Napier, the inventor of logarithms, painted in 1616

[1] Scottish Record Office, Accounts of the Treasurer of Scotland, E 21/76, fo. 276.
[2] For illustrations of this type of work see M. R. Apted, *The Painted Ceilings of Scotland 1550–1650*, 1966.

(no. 31), there is a curious mixture of international mannerism and a purely provincial vision. Portraits of a completely provincial kind also became rather commoner during this decade (see nos. 28–30), evidence that a demand for family portraits was growing and spreading within the community, a demand which Jamesone would satisfy almost single-handed in the following three decades. This almost purely native style, which Jamesone supplanted, retained some life into the 1620s (see no. 33).

By far the most intriguing of the decorative painters is John Anderson, though the only real evidence of his work is the decoration of the small room in Edinburgh Castle in which, traditionally, James VI was born. A native of Aberdeen, Jamesone was apprenticed to him in Edinburgh in 1612. This ought to be one of the key facts in the history of painting in Scotland during the period but its significance is difficult to estimate since it is not possible to relate the work of master and pupil. Jamesone's early style may be simply a development of an Anderson portrait form with an admixture of what he knew of the work of London painters like de Critz, Peake, or Gheeraerts. Yet the records of Anderson's work during the decade in which Jamesone was his apprentice point to purely decorative painting, ranging from clock shutters in Edinburgh to an emblematic ceiling and a chapel painted with 'parables and other sacred subjects' at Huntly Castle in 1617. The Marquess of Huntly evidently had a very high opinion of him, as did Sir John Grant of Freuchie when Anderson was about to decorate his gallery at Ballachastel in 1634. The few surviving letters between these two hint at a surprising degree of intimacy: they also mention portraits which Anderson was having framed for Grant, unfortunately stating neither who the portraits were by nor the identity of the subjects. Anderson outlived his famous pupil by more than five years, having witnessed a revolution in taste for which the pupil had been largely responsible, but in which Anderson's own part is still not quite understood.

That Jamesone in some degree always remained part of the decorative painters' world is witnessed by his family connections with them and with personal contacts over a long period with painters like Andrew Strachan—and also by the nature of some of the work he was doing in the mid-1630s when his fame as the unique portrayer of contemporary Scots must have been considerable—a 'rara avis in nostris oris' according to the schoolmaster Wedderburn. This work included the series of hastily painted kings (see nos. 63–4) which were set up in Edinburgh in the summer of 1633 for the triumphal entry of Charles I, soon to pursue ecclesiastical policies as disastrous as his father's had been successful. The rapid handling and the high-keyed colours of these pictures, vermilions, blues, and apple greens, are nearer to the decorative painter's repertory of effects than to the more highly wrought, tonally sensitive of the best of Jamesone's own conventional portraits. Jamesone may indeed be seen as the leading figure in a group of decorative painters who were engaged in the feverish preparations for the king's visit: Anderson, James Workman, and John Sawers in the Castle, Anderson, Workman, and Robert Telfer at Holyroodhouse, with Mungo Hanginschaw from Glasgow and an English painter, Valentine Jenkin, also active. Jamesone was involved in the painting of the king's loft in St Giles, though it was 'his man' who did the actual work, the materials used not the usual tempera but oil colours and gold-leaf.

A work which also tends to be part of the decorative tradition is the large family-tree painted in 1635 for Sir Colin Campbell of Glenorchy (no. 66). Though it is of an unparalleled complexity and contains a series of simulated framed portraits which hang rather uneasily on the trunk of the tree, it is basically heraldic and decorative in conception. Indeed, the entire programme of work which Jamesone carried out for Campbell, series of portraits of ancestors, monarchs, and contemporaries (see nos. 67–9), has a decorative aspect as well as an iconic one and was probably directly inspired by the decorations erected in Edinburgh in 1633.

Yet Jamesone to a large degree had established almost single-handed a

modern, psychological type of portrait in Scotland and this at a time when work of this sort in England was still largely the product of immigrant painters from the Low Countries. But for the rather unexpected appearance of Jamesone this pattern might have been repeated in Scotland, though on a much reduced scale, in the person of Adam de Colone, not exactly an immigrant, but the son of one, Adrian Vanson, who had worked at the earlier Scottish court. Though born and reared in Scotland, de Colone almost certainly had his entire training abroad, returning to London in 1622 and coming to Scotland in the last few months of 1624.

Few paintings survive from Jamesone's earliest years when his subjects were found among the academic and middle-class circles of Aberdeen. One of the best of these decidedly provincial works is the *Unidentified Man* of about 1624 (no. 59), sensitive, the head created by subtly modulated light, the conception refreshingly empirical. Within a short time the circle of his patronage widened considerably to include the leading noble families of the country and he appears to have slightly bemused those who watched his rapid rise to fame. This is expressed in a variety of Latin verse, published from 1632 onwards, which celebrated in highly inflated terms 'the skill of a hand that emulated the Flemings and the Italians'.

His earliest attempts at a grander manner in the Jacobean court tradition of Marcus Gheeraerts are two full-lengths of the Earl and Countess of Rothes in interiors of 1625 and 1626 respectively.[1] Though they have some charm and a few isolated passages of beauty, the drawing is singularly ill-conceived, so that the figures have a far greater degree of awkwardness than in comparable paintings by Gheeraerts, which themselves never quite attained the firmly anchored pose in a rational space which Paul van Somer and Daniel Mytens had introduced into English painting from about 1617 onwards. Jamesone appears to have realized his limitations and thereafter normally restricted himself to simple head and shoulders arrangements, rather in the manner of his Netherlandish contemporary in England, Cornelius Johnson. He did attempt something similar once more, though on a reduced scale, in the late 1630s in the Haddington family-group (no. 71) but, despite the miniature-like delicacy and quite subtle atmospheric effects, the same faults are evident.

His finest surviving portraits are those of the Countess Marischal of 1626 (no. 60) and the Earl (later Marquess) of Montrose of 1629 (no. 62) where there is a satisfying balance between the painter's pretensions and his means. In both paintings, colour, tone, and texture are held in a fine control; and, while the images ultimately lack the totally convincing density of some comparable Dutch portraits of the period, the sitters have a real if slightly tremulous existence and are subject to light and atmosphere within the possibility of change. It is this sensitivity to nuance which is Jamesone's peculiar gift and distinguishes him from his Anglo-Netherlandish contemporaries whose methods, superior in many other respects, especially technical ones, tend by comparison to follow an *a priori*, rather authoritarian approach.

Nevertheless, these portraits are not free of the influence of Netherlandish formulae and it is likely that in the mid-1620s Jamesone was very considerably influenced by Adam de Colone and that it was through him that certain features of the London court style were channelled. De Colone's manner has a solid continental foundation lying near to the Miereveld tradition. It derives more immediately, however, from the Anglo-Netherlandish painters, Gheeraerts and van Somer. One of his most accomplished portraits, that of Lord Melrose, later Earl of Haddington, of 1624 (Tyninghame) is close in conception to Gheeraerts's portrait of Richard Tomlins of 1628 (Oxford, Bodleian Library), though it is rather more austere and lacks something of the delicate perceptiveness of the latter portrait. In terms of weight of pigment (often handled rather dryly) and solidity of form, van Somer is a closer parallel, indeed so close that there is a temptation to suggest some connection between them. These particular qualities are embodied in a very similar

[1] Formerly in Leslie House: now in the possession of the Fine Art Society.

fashion in de Colone's *Countess of Dunfermline* (no. 53) and the former's *Countess of Kent* (Tate Gallery). The curious diagonal bias found in the figure of Anne of Denmark in van Somer's full-length portrait of the queen of 1617 (Windsor) is also a distinctive feature of much of de Colone's work— for instance, the portrait of the Earl of Buchan (no. 51) and his masterpiece, the group portrait of the Earl of Winton and two of his sons (no. 49). In this latter portrait the compact, tightly integrated forms are the means for creating a deeply moving expression of family union and tenderness, the mood of austerity and profound gravity softened by the warm colour. The interlocking arms, the subtle differentiation of age and experience, even the care given to the depiction of the incidental detail of the costume, are all suggestive of a touching human awareness on de Colone's part.

The rediscovery of de Colone's identity is of the greatest significance for the history of Scottish painting and makes Jamesone seem a much less isolated figure than was believed. It also clarifies the true limits of Jamesone's style, for until recently most of de Colone's paintings were attributed to him. Given Jamesone's great contemporary fame it is certainly a curiosity of art history that de Colone's existence has been so long and so effectively obliterated. It is unclear how much of his later life was actually spent in Scotland: though a passport was issued to him in February 1625 so that he could make a journey to the Low Countries on the understanding that he would return to settle in Scotland, it is not known if he made such a journey, either soon after that date or after 1628 when his last known portraits are dated. His sitters, where they have been positively identified, are exclusively Scottish and many of them were frequently in London; it is, therefore, possible that the greater part of his active career was spent there, though this is by no means certain. In any case, de Colone's career suggests a number of intriguing possibilities in Scottish painting that because of his sudden disappearance could not be fulfilled. If he had remained and Jamesone had had real competition from a painter who was basically more skilful, would Jamesone have become the nationally renowned figure that he did? Would he have avoided the haste and carelessness that set in all too soon? How much would their styles have ultimately modified each other? If, as seems likely, this kind of situation had been fruitful, would it have improved the taste of patrons to such a degree that they would demand more variety; and would they have been less content to accept the reversion to the thorough provincialism which painters like the Scougals and even the foreigner Schuneman were to purvey after the middle of the century? Though these questions cannot be answered, they suggest that the decade in which de Colone was active marks an important turning point in the history of painting in Scotland.

By the mid-1630s Jamesone was exceptionally busy, indeed overworked, and the quality of his painting suffered through the near-monopoly he now held. Nevertheless, there were moments of achievement, such as the powerful portrait of the Earl of Southesk of 1637 (no. 70). The year before this, Michael Wright had come north to be apprenticed to him, a situation also inherent with possibilities which were not to be realized. A period of social upheaval, set in motion by Charles I's ecclesiastical policies, was also about to succeed the years of peace, which had been the achievement of the king's father. Jamesone was caught up in this turmoil, being imprisoned for a time in 1640 for supposed opposition to the 'good cause' of the covenanters. His death coincided with the sack of Aberdeen by Montrose in 1644 at the end of the first phase of the troubles. Towards the end of his life he had produced very little, his own wealth and the increasing chaos no doubt being the principal causes.

It is worth remarking that in the years spanned by Jamesone's career only four painters are recorded in Scotland who were capable of portraiture— Jamesone himself, Adam de Colone, the so-called 'German painter' who had worked for Campbell of Glenorchy, and Michael Wright. There are traces of others but only one coherent body of work can be detected, the few paintings attributed to a painter active in the years 1633–7 whose rather feeble manner

seems to owe something to both de Colone and Jamesone (see nos. 54–7).

While Michael Wright was no doubt attracted to Edinburgh by that torch, which for the poet Wedderburn symbolized Jamesone's fame and achievement, it is impossible to say how valuable the experience was, though he presumably learned certain fundamentals of his art. His painting has a freshness and unstrained vivacity which distinguish him from many of his contemporaries in England and which may hint at his unconventional origins. How soon and how untraceably the marks of his early career were overlaid by his uniquely first-hand knowledge of the great European painters of the mid-century is a question that must remain unanswered. However, in one sense at least when viewed in the wider British context, as a native painter on a stage still dominated by foreigners, he became part of that same movement towards an indigenous style which his master Jamesone had represented.

A portrait of the 4th Earl of Haddington (no. 75), simple and quite free of extravagance, may represent his work in Scotland. No certain works, however, are known before 1658, in which year he appears to have returned to England after many years in Rome and on the continent. He was patronized by certain of the Scots nobility immediately after the Restoration (see nos. 76 and 78), and this may be more than mere coincidence, but by then his memories of Scotland must have been dim.

Catalogue

Measurements are given in inches, followed by centimetres in brackets, height preceding width. Two frequently occurring abbreviations are: SRO (Scottish Record Office) and GRO(S) (General Register Office, Scotland).

Lieven de Vogeleer

flourished 1551-1568

Presumably the painter who was made a freeman of the Antwerp guild in 1551. He is known only by the *Memorial of Lord Darnley* (no. 1), which was painted in London in January 1567/8. A painter of the same name recorded at Brussels in 1600 may or may not be the same person. A portrait of Sir John Leman dated 1616 in the royal collection which has been associated with a painter called 'Levinus' or 'Leevines' may indicate that Lieven de Vogeleer flourished over a much longer period than is certainly known.[1]

REFERENCES (1) Oliver Millar, *The Tudor, Stuart and Early Georgian Pictures in the Collection of Her Majesty The Queen*, 1963, Text, pp. 71-2, 75.

1 The Memorial of Henry Stewart, Lord Darnley, King of Scots (1545-1567)

Canvas: 56 × 88¼ (132.1 × 224.2)
Signed on the altar step: *Livinus Voghelarius* . . . (remainder indistinct). There are ten Latin and three English inscriptions in various parts of the picture (see below).

Provenance: presumably by descent to Charles, Duke of Richmond and Lennox (d. 1672); thence through his sister Lady Katherine O'Brien to her daughter-in-law, Lady Sophia O'Brien, and her son by her second marriage, Thomas Fermor, 1st Earl of Pomfret; given by Lord Pomfret to Queen Caroline, probably in 1736.

Exhibitions: Royal Academy, *British Portraits*, 1956/7, no. 21; Edinburgh, *Renaissance Decorative Arts in Scotland 1480-1650*, 1959, no. 72.

Literature: 'Vertue Note Books', *Walpole Society*, vol. xx (II), 1932, p. 25; ibid., vol. xxiv (IV), 1936, p. 124; ibid., vol. xxx (VI), 1955, p. 105; Horace Walpole, *Anecdotes of Painting in England*, 1876, vol. i, pp. 183-4; Ellis Waterhouse, *Painting in Britain 1530 to 1790*, 1962, pp. 28-9; Eric Mercer, *English Art 1553-1625*, 1962, pp. 163-4; Millar (cited above), pp. 13-14, and no. 90.

Lent by Her Majesty The Queen

The inscription on the tablet hanging on the extreme right, headed OPERIS HVI(V)S CAVSA—'the reason for this work'—states that the painting was commissioned in London in January 1568 (1567 old style) by the Earl and Countess of Lennox so that 'if they, who are already old, should be deprived of this life before the majority of their descendant, the King of Scots, he may have a memorial from them, in order that he shut not out of his memory the recent atrocious murder of the king his father, until God should avenge it through him'.

In the centre, the effigy of their son Darnley lies on an elaborate tomb facing an altar on which stands a statue of the victorious Christ. At his head two unicorns bear the Scottish crown—he is referred to as the King of Scots throughout the picture. In the centre of the sarcophagus are the royal arms of Scotland, while on the outsides are Darnley's paternal and feudal arms. Between these arms are two simulated circular reliefs, each with a brief inscription describing the events depicted: the one on the left shows Darnley and his servant assassinated in their bed, while that on the right shows their bodies lying in the garden at Kirk o' Field.

Beyond the effigy hangs a tablet inscribed with a verse epitaph on the murder of 'Henry, King of Scots . . .

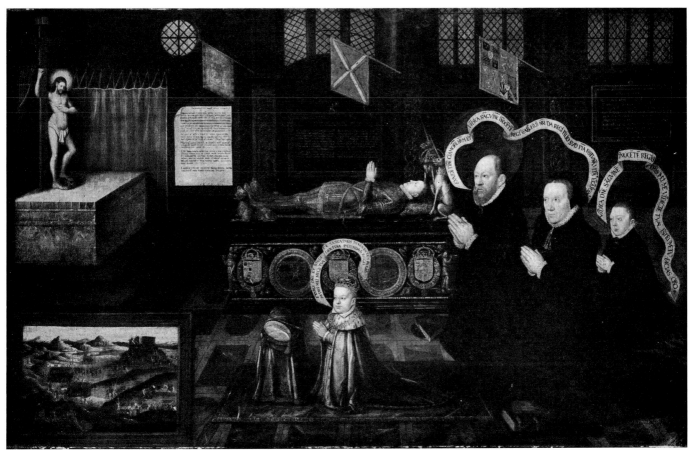

whom you now see depicted here'. Darnley, 'filled with the countless gifts of a noble mind', is praised in the most fulsome terms. Reference is also made to his son, 'a king of uncommon hope', and, more sinisterly, to the conspiracy of Mary with those who had put out 'this golden light'.

To the left hangs another tablet bearing a simulated sheet of paper which lists the protagonists in the painting, their ancestry and their dynastic significance. It is also stated explicitly that Darnley was murdered by Bothwell and his fellow conspirators 'with the consent of his wife the queen, which queen straightway became the wife of the said Bothwell after her loving and most faithful husband's murder'.

In the middle foreground kneels the potentially most significant of these protagonists, an incredible infant King James VI, wearing the crown. From his mouth a scroll proclaims the principal message of the picture, one of a series of bloodcurdling and near-blasphemous calls for revenge: EXVRGE DOMINE ET VINDICA SANGVINEM INNOCENTEM REGIS PATRIS MEI MEQ(UE) TVA DEXTERA DEFENDAS ROGO— 'Arise, O Lord, and avenge the innocent blood of the king my father and, I beseech you, defend me with your right hand'. Behind him kneel the Earl and Countess of Lennox and their son Charles who utter similar sentiments, Charles praying that he be made the instrument of God's revenge.

In a painting within the painting, in the lower left corner, is depicted the encounter at Carberry on 15 June 1567 where Mary surrendered without struggle to the confederate lords. The lords, moving from left to right (within an idealized Flemish, rather than a localized Scottish landscape), bear a banner showing Darnley's corpse, with the inscription: IVDGE AND REVENGE MY CAVSE O LORD. On the extreme right two tiny horsemen represent the Earl of Bothwell and a servant leaving the field—*Boithwillis departing*—while to the right of the central hill on the horizon we see *Boithwill fleand*. Around the frame of the simulated picture is a further Latin inscription, aimed at the traitorous and profligate Bothwell.

Besides being a call to revenge, the picture is also clearly intended to besmirch Mary's reputation and destroy her credibility. This is done partly by implication but also quite explicitly in, especially, the sheet of paper next to the altar. The most offensive lines, 3, 5, and 6, have been obliterated at some subsequent date, perhaps soon after James's accession to the English throne, when he started to rehabilitate his mother's memory.

It is a painful and depressing commentary on the kind of civilization that Scotland had attained in the sixteenth century that perhaps the finest product of its artistic patronage should have been created for such potentially vicious ends. The programme of the painting has been worked out with the greatest attention to detail, presumably by the Earl and Countess of Lennox (it would be interesting to know who composed the Latin verses), so that it can be read as a mounting wail of despair for the death of a son and a deafening call for revenge on all concerned. Yet the picture does not represent a formal equivalent for these emotions. The serene heads of the Earl and Countess and their no less expressive hands are parts of a splendid and pious solemnity, redolent of the intense devotion of the Flemish donor portrait of the previous century. The delicacy of detail throughout the chapel is also part of that tradition, where the diverse works of man seem to gleam with a divine inner radiance and are also revealed by a flawless external source of light. But here such a vision serves not a transcendental view but rather a single-minded obsession with the immediate concerns of flesh; it reveals not mystery but a man torn from his bed and his corpse laid out in a garden.

There is another version of this picture at Goodwood where the inscriptions referring to Mary are undamaged: these have been used to produce parts of the translations given above.

A Series of Monarchs

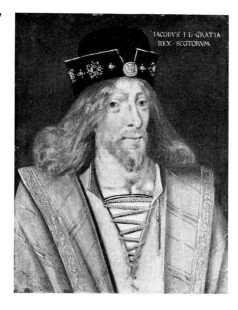

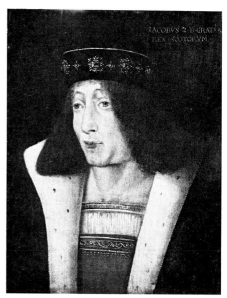

2 James I (1394–1437)

Panel: 16¼ × 13 (41.2 × 33)
Inscribed top right: IACOBVS . I . D . GRATIA /
REX . SCOTORVM

3 James II (1430–1460)

Panel: 16¼ × 13 (41.3 × 32.9)
Inscribed top right: IACOBVS . 2 . D . GRATIA /
REX . SCOTORVM

Provenance: early history unknown; purchased from D. J. S. Lyell of St Andrews, 1909.

Literature: James L. Caw, 'Portraits of the First Five Jameses', *The Scottish Historical Review*, January 1910, pp. 113–118.

Scottish National Portrait Gallery

Portrait series of kings, heroes, and famous men are a common form from the Renaissance onwards, often associated with the earliest stages of the development of the art of portraiture. The individual portrait in Italy was itself a development from the occurrence of portrait groups in contexts where another subject, religious or perhaps civic, was paramount. On occasion the portrait appears to be an irrelevant intrusion, the architect Alberti, for instance, taking the part of Noah in Uccello's *Flood* (fresco: Florence, convent of Santa Maria Novella), or the members of a prominent family adoring the Virgin and Child. On occasion the participants might have been dead for some time when the picture was painted—there was clearly a need, however, to preserve at all costs and from whatever information remained, the appearance of the individual and his ideal role in life. An aspect of this is the belief (one, unfortunately, never quite eradicated) that history is the creation of great men. From this it is a step to such self-contained series of 'uomini famosi' as the group of 300 full-lengths (now destroyed) commissioned by the cardinal Giordano Orsini for the Orsini palace in Rome in the 1430s and which traced the entire

course of world history (see Robert L. Mode, 'Masolino, Uccello and the Orsini "Uomini Famosi"', *The Burlington Magazine*, vol. cxiv, 1972, pp. 369 ff.). A more palatable example is the single horizontal panel, perhaps by Uccello, depicting five of the founders of Florentine art, each with his name inscribed beneath (Paris, Louvre). There is thus from the beginning a tradition that portraits can complement each other and that they can transcend the effects of time in two important ways, by becoming permanent records of particular faces and by linking those long dead with their inheritors in the present.

Such series, though in aesthetic terms immensely more primitive, had certainly appeared in England by the end of the fifteenth century—usually royal subjects but occasionally ecclesiastics, scholars, or holders of certain offices (see E. C. Murray, *Decorative Painting in England 1537–1837*, vol. i, 1962, pp. 14–16, 158–9, 174, 176). By the seventeenth century it was not unusual to find them used in conjunction with triumphal arches, purely temporary structures erected on the occasion of a triumphal entry to a city by a prince or monarch. The type of painting involved was itself ephemeral yet it was often the work of the most important painters of the day—Rubens, for example, prepared the decorative schemes set up in Antwerp in 1634–5 for the triumphal entry of the Cardinal-Infante Ferdinand (see John Rupert Martin, *The Decorations for the Pompa Introitus Ferdinandi*, 1972). The Flemish *blijde intrede*, or something akin to it, had reached Scotland by the sixteenth century. On Mary, Queen of Scots' entry into Edinburgh in 1561 she

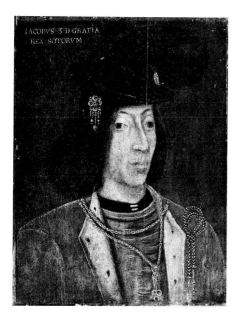

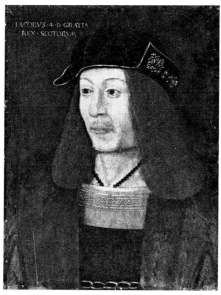

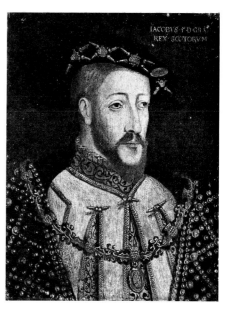

4 James III (1457–1488)

Panel: $16\frac{1}{16} \times 12\frac{7}{8}$ (40.8 × 32.7)
Inscribed top left: IACOBVS . 3 . D . GRATIA /
REX . SCOTORVM

5 James IV (1473–1513)

Panel: $16\frac{1}{4} \times 13$ (41.2 × 33)
Inscribed top left: IACOBVS . 4 . D . GRATIA /
REX . SCOTORVM

6 James V (1512–1542)

Panel: $16\frac{1}{4} \times 13$ (41.3 × 33)
Inscribed top right: IACOBVS . 5 . D . GRATIA /
REX . SCOTORVM

passed through a painted arch to be met by a child who stepped from a descending quatrefoil cloud holding the keys of the city. By far the best documented triumphal entry into Edinburgh was that of Charles I in 1633 for which George Jamesone provided a series of Scottish monarchs, perhaps as many as the 109 which were fixed to the second triumphal arch at the Tolbooth (see nos. 63–4).

The present series has every appearance of being the whole or part of such a group. There are other sets of the same pattern and the images were very much standardized (see the notes on Jamesone's *James III*, no. 64), presumably long before the present set was painted. Caw believed that they may have been painted during the life of James V, who died in 1542, but it is difficult to believe that they are as early as this. They are certainly primitive and iconic—only in the *James I* is there a trace of sentience; however, even where art of a far higher order was concerned, it was never the intention in series of this sort to probe the psychology of an individual but rather to record the lineaments of his face. If they were intended to be fixed on a triumphal arch this degree of lifelessness would accord with their function. The triumphal entry with which they can most credibly be connected is that of James VI in 1579. It is recorded that 'the forehowsis of the streits be the whilks [by which] he passit, war all hung with magnifik tapestrie, with payntit historeis, and with the effegeis of noble men and wemen'; at the Salt Market Cross was an arch 'quharupon [whereon] was erectit the genealogie of the Kings of Scotland' (*Documents Relative to the Reception at Edinburgh of*

the Kings and Queens of Scotland 1561–1590, edited Sir Patrick Walker, pp. 30–31). This genealogy may well have meant, as it did in 1633, a series of portraits and these five may be the remnant. Though they are primitive, it is probably necessary to connect them with a foreign painter, but no name presents itself for they are not to be connected with Bronckorst or Vanson.

Arnold Bronckorst

flourished 1565/6-1583

This painter's name has become known in a variety of forms, van Bronckhorst, Bronckhorst, Bronckorst, van Brounckhorst, and van Brounckhurst. Neither in the two known signed pictures nor in the largest body of contemporary records which refer to him, the Accounts of the Treasurer of Scotland, is the preposition used. In the circumstances, the form he himself used on the portrait of Baron St John of Bletso has been preferred. There is also some confusion about his Christian name as the metallurgist, Stephen Atkinson, author of the most informative record of Bronckorst, refers to him as Arthur.[1] The last record of Bronckorst, his residence in the Langbourne ward of London in 1583 when he is described as a 'Dutche Painter', also gives the Christian name as Arthur.[2] The strength of other evidence suggests that these are simply errors—Atkinson, it should be noted, was writing as late as 1619.

The earliest probable record of Bronckorst is a payment for a portrait of Sir Henry Sidney in 1565/66.[3] There is no record of Bronckorst in Scotland before April 1580, when he was paid £130 for 'certane portratouris paintit be him to his grace'.[4] However, as has been suggested, he may have been in Scotland before this date if the portrait of James VI was painted in 1574 (see no. 8 below). On 9 September 1580 the king ordered the treasurer to pay him £64 for three pictures 'delyverit laitlie to his hienes', a portrait of the king himself 'fra the belt upward', a portrait of George Buchanan, and a full-length of the king.[5] However, we learn from Stephen Atkinson that Bronckorst had not come to Scotland primarily to paint portraits but to prospect for gold. He had been sent as an agent for the miniaturist Nicholas Hilliard in the company of another painter, Cornelius de Vos. The search met with some success but Bronckorst seems in some way to have fallen foul of the regent, the Earl of Morton, and, as a result, been forced by necessity to take up service as 'one of his Majesties sworne servants at ordinary in Scotland, to draw all the small and great pictures for his Majesty'. The grant of the office was made to him on 19 September 1581 'for all the dayis of his Lyvetime'.[6] His half-yearly pension or fee of £50 is entered regularly in the Treasurer's Accounts until Martinmas 1583. At the following term, Whitsun 1584, Adrian Vanson appears in the same record 'in place of Arnold Brukhorst'.[7]

REFERENCES (1) Stephen Atkinson, *The Discoverie and Historie of the Gold Mynes in Scotland, written in the year 1619*, Bannatyne Club, 1825, pp. 33–5. (2) *Returns of the Aliens Dwelling in the City and Suburbs of London*, Huguenot Society, vol. x, pt. ii, 1900, p. 336. (3) The main references to contemporary sources other than those given here are in Erna Auerbach, *Tudor Artists*, 1954, pp. 151–2. (4) SRO, Accounts of the Treasurer of Scotland, E 21/61, fo. 19. (5) Ibid., fo. 43, and E 23/5/6. (6) SRO, Register of the Privy Seal, PS 1, vol. xlvii, fo. 40. (7) SRO, Accounts of the Treasurer of Scotland, E 21/62, fo. 162v.; E 21/63, fos. 46, 95; E 22/6, fos. 97v., 134, 184.
See also the following: Erna Auerbach, *Nicholas Hilliard*, 1961, pp. 17–18, 265–71; Roy Strong, *The English Icon*, 1969, pp. 135–8; D. Thomson, *The Life and Art of George Jamesone*, 1974, pp. 44–6.

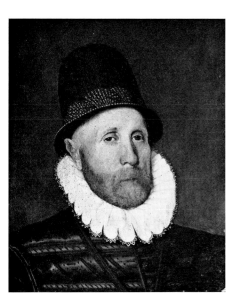

7 Oliver St John, 1st Baron St John of Bletso (d. 1582)

Panel: $18\frac{1}{2} \times 15\frac{1}{2}$ (47.1 × 39.4)
Signed vertically down right edge: AR
[monogram] BRONCKORST FECIT 1578

Provenance: by descent in the sitter's family; sold Christie's, 17 May 1955, lot 19.

Exhibition: Tate Gallery, *The Elizabethan Image* (catalogue by Roy Strong), 1969, no. 52.

Literature: Erna Auerbach, 'Some Tudor Portraits at the Royal Academy', *The Burlington Magazine*, vol. xciv, 1957, p. 10; Auerbach (1961, cited above), pp. 266–7; Strong (1969, cited above), p. 136; Thomson (cited above), p. 45.

Lent by the Honble. Hugh Lawson Johnston

Presumably painted shortly before Bronckorst left for Scotland, this picture is the principal guide to identifying other paintings by him. Strong (1969, exhibition catalogue) has described Bronckorst's manner as 'a feeble style based on that evolved by Antonio Mor', a view which hardly takes account of the particularized and refined drawing of the sitter's head in this portrait, the subtlety of the implication of bone behind the skin and the consequent feeling of psychological truth. These qualities, as well as the economy of tonal variation, establish a link with the finest Hilliard miniatures of the 1570s. The closeness of Bronckorst's relationship to Hilliard is not absolutely clear, but Atkinson does appear to say that he was Hilliard's 'servant and friend'.

8 James VI of Scotland I of England (1566–1625) holding a Hawk

Panel: $18 \times 12\frac{1}{16}$ (45.7 × 30.6)
Inscribed along top edge: IACOBVS.
Charles I's cipher branded on reverse.

Provenance: Robert Young; given by him to Charles I; sold 23 October 1651 but recovered at the Restoration; later in the Breadalbane collection with R. Baillie Hamilton at Langton House, Duns; sold by Lieut.-Col. Thomas Breadalbane Morgan-Grenville-Gavin at Christie's, 27 March 1925, lot 12.

Exhibitions: London, New Gallery, *Royal House of Stuart*, 1889, no. 57; Royal Academy, *Kings and Queens*, 1953, no. 112; Tate Gallery, *The Elizabethan Image*, 1969, no. 50.

Literature: Auerbach (1961, cited above), p. 269; 'Abraham van der Doort's Catalogue of the Collections of Charles I', edited by Oliver Millar, *Walpole Society*, vol. xxxvii, 1960, pp. 65, 232; Oliver Millar, *The Tudor, Stuart and Early Georgian Pictures in the Collection of Her Majesty The Queen*, 1963, Text, p. 14; Strong (1969, cited above), p. 137; Roy Strong, *Tudor & Jacobean Portraits*, 1969, pp. 176, 178; Thomson (cited above), p. 45.

Scottish National Portrait Gallery

This picture was first attributed to Bronckorst by Auerbach. It has suffered a good deal of damage but still shows much of the same tender exactitude of draughtsmanship as the portrait of Lord St John. It is tempting to equate it with the portrait of the king 'fra the belt upward', for which a payment to Bronckorst is recorded in September 1580. Strong (1969, *Tudor & Jacobean Portraits*), however, argues that it is a cut-down portrait of 1574, the original full-length format of which is known in two copies bearing that date at Hardwick and the National Portrait Gallery. Technical evidence does not suggest that it has been reduced in size. Further, if it is indeed the same portrait as that recorded by van der Doort, who describes the picture as 'king James the 6th . . . when hee was but 5 years of age in a black Capp and white feather, haveing upon his left fist a glove, and a Martin thereon', the dimensions agree closely (18 × 13 inches). This implies that it must have been cut down by a surprisingly early date.

If the picture was commissioned outwith the court, this would explain the absence of any reference to Bronckorst in the Treasurer's Accounts in 1574, but the circumstances in which Bronckorst might have come north on an isolated occasion to paint the king and yet failed to be employed at court remain obscure, and rather odd. It is just possible, however,

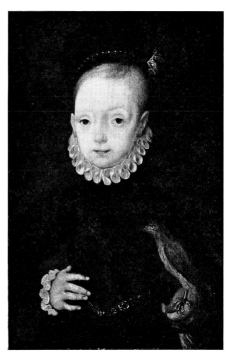

that he is intended by the Treasurer in his reference to a 'Frenche panter' who was paid £10 in September 1573 for a portrait of the king (see *Accounts of the Treasurer of Scotland*, vol. xii, 1970, p. 361). The king's age is difficult to estimate, partly because of damage. (Van der Doort's estimate, it should be noted, would make the portrait even earlier, about 1571.) The king certainly seems quite young but, given the immaturity of some adolescents, it is not inconceivable that he might be as old as thirteen or fourteen.

The bird which van der Doort describes as a martin is, in fact, a male sparrowhawk, the bird which a falconer would call a musket. Hawking was one of the king's favourite pursuits—indeed he was hawking in Glasgow at the time he granted Bronckorst the office of painter.

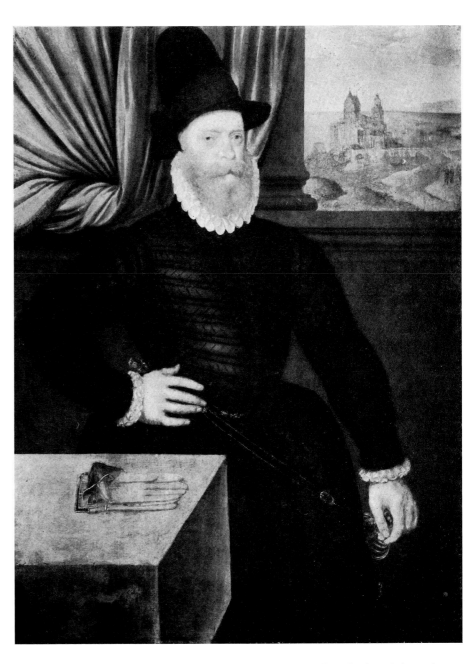

**9 James Douglas, 4th Earl of Morton
(c. 1516–1581)**

Panel: 41¾ × 32 (105 × 81.4)

Provenance: the Earls of Morton until
sold in 1959.

Exhibitions: Edinburgh, *Loan Exhibition*,
1883, no. 62; Tate Gallery, *The Eliza-
bethan Image*, 1969, no. 51.

Literature: Sir Herbert Maxwell, *A
History of the House of Douglas*, 1902,
vol. i, p. xxviii; James L. Caw, *Scottish
Portraits*, 1903, vol. i, pp. 46–7; L. Cust,
'The Painter HE (Hans Eworth)', *Wal-
pole Society*, vol. ii, 1913, p. 44; Auerbach
(1961, cited above), p. 269; Thomson
(cited above), pp. 45–6.

Scottish National Portrait Gallery

This picture was also first attributed by
Auerbach. Despite a good deal of
damage, it displays some of the same
delicacy of drawing and mood and un-
pretentious solemnity as Bronckorst's
portraits of Lord St John and the king.
The similarity of the forms of the hands
to those of the king is particularly marked
—the left hands angular, the right hands
plump yet sinuous in a rather northern-
mannerist way, and falling into exactly
the same pattern.

According to Atkinson, Bronckorst had
negotiated, unsuccessfully, with Morton
over a period of four months in an
attempt to remove from Scotland the gold
he had discovered. Morton, earlier im-
plicated in the murders of both Riccio
and Darnley, became regent in November
1572 and for a time established stable
government. His regency came to an end
in the spring of 1578, though he main-
tained control for some time after. With
the ascendancy of Esmé, Duke of Lennox
he was arrested in December 1580 for his
part in Darnley's murder and executed in
June 1581. If, as seems likely, the portrait
was painted in his days of power, this
would tend to place the beginning of
Bronckorst's sojourn in Scotland at least
as early as 1578. A rather poor head and
shoulders version in the Scottish National
Portrait Gallery bears a date 1577.

Adrian Vanson
(or Van Son)
flourished 1581-1602

Adrian Vanson (the naturalized version of his name) had replaced Bronckorst as painter at the court by May 1584.[1] His Netherlandish origins are not known. Like Bronckorst, he was employed at court before being granted an office. In June 1581 he was allowed a payment of £8 10s. for two pictures (presumably small) which were despatched to Theodore Beza in Geneva[2] (see nos. 10 and 11 below), while in May 1582 he was paid £20 for 'certane paintrie'.[3] Vanson's fee was entered regularly in the Treasurer's Accounts (though it was not necessarily paid) until Martinmas 1586.[4] It is not clear why this payment was stopped—nor was it clear in 1610 to Vanson's widow Susanna de Colone (Declony) when she petitioned the king 'alsueill [as well] for wages as work done'.[5] In December 1587 and May 1590 there are specific payments for painting banners, on the latter occasion a sum of £66 13s. 4d. for trumpeters' banners at the queen's coronation.[6] The last record of this type is a payment of £20 in December 1601 for a miniature portrait of the king which was attached to a gold chain specially made by George Heriot for despatch to the Duke of Mecklenburg. The chain itself cost over £600.[7]

Vanson's appearance in Scotland seems also to have had some significance at a civic level, for in December 1585 he was admitted as a free burgess of Edinburgh 'for seruice to be done to the guid towne', and also under the condition that 'he tak and Instruct prenteisses'.[8] It is difficult to estimate the effects of this condition, if fulfilled, but it may have been responsible for inducing some of the decorative painters towards the production of portraits.

A fair amount is known about Vanson's personal life. It is likely that he was related to the Edinburgh goldsmith Abraham Vanson.[9] He appears to have had close links with Sir Adrian van Damman, formerly a professor at the University of Leiden and from 1584 ambassador from the Confederate Provinces at the Scottish court. In May 1594 they together stood surety in sums amounting to £3,000 regarding the activities of three Dutch sailors, one of whom, Hendrick Michelsoun, was confined to Vanson's house until the king should release him.[10] Van Damman was also a witness to the baptism of Vanson's son Adrian on 19 October 1595.[11] Vanson had at least three other children, Susanna, James, and Frederick.[12] It is, however, now almost certain that he had a son Adam, probably born a year or two before 1595, who assumed his mother's name de Colone when she became a widow[13] and who flourished as a painter in the 1620s.

In the last two decades of the century Vanson appears to have been the only painter at court to undertake portraiture and for this reason it seems likely that any relatively sophisticated royal portraits must be from his hand. It is on this assumption that the paintings below, which seem coherent, are attributed to him. A more precise description of them might be speculations rather than attributions.

REFERENCES (1) SRO, Accounts of the Treasurer of Scotland, E 22/6, fo. 184. (2) Ibid., E 21/62, fo. 135v. (3) Ibid., E 21/63, fo. 40. (4) Ibid., E 22/6, fo. 219; E 21/64, fo. 69; E 21/65, fo. 105v.; E 21/65, fo. 64v.; E 21/65, fo. 101v. (5) National Library of Scotland, Adv. MS. (Denmilne MSS.), 33. 1. 1/40. (6) SRO, Accounts of the Treasurer of Scotland, E 21/66, fo. 92, and E 21/67, fo. 202. (7) Ibid., E 21/75, fos. 89, 90v. (8) *Extracts from the Records of the Burgh of Edinburgh 1573–1589*, 1882, p. 446. (9) He was witness at the baptism of one of Abraham Vanson's children in September 1596: GRO(S), Old Parochial Registers, Edinburgh, vol. i, fo. 26v. (10) *Register of the Privy Council of Scotland*, vol. v, 1882, p. 622. (11) GRO(S), OPR, Edinburgh, vol. i, fo. 9. (12) Ibid., fos. 32, 59v., 101: on the evidence of the register of baptisms other immigrants in Vanson's circle were Adrian Bowdingis, a clockmaker, Ambrosius Lerice, Jacques de la Bargue, and Peter Zippis, all merchants. (13) The last record of Vanson is his appearance as witness to a baptism on 17 October 1602: GRO(S), OPR, Edinburgh, vol. i, fo. 116. See also: D. Thomson, *The Life and Art of George Jamesone*, 1974, pp. 46–8.

10 James VI of Scotland I of England (1566–1625)

Wood engraving: $5\frac{1}{8} \times 4\frac{1}{8}$ (13 × 10.4). Frontispiece to Theodore Beza's *Icones, id est Verae Imagines, Virorum Doctrina simul et Pietate Illvstrium* . . ., Geneva, 1580.

Literature: Thomas Carlyle, 'The Portraits of John Knox', *Fraser's Magazine*, April 1875, pp. 102, 110; P. Hume Brown, *John Knox*, 1895, vol. ii, pp. 320–324; Thomson (cited above), p. 46.

Lent by the National Library of Scotland

This is assumed to be after one of the two portraits by Vanson which were despatched to Beza in Geneva some time before the allowance of £8 10s. was entered in the Treasurer's Accounts in June 1581. The king's interest in the work, which is dedicated to him, is referred to in a letter sent to Beza by Peter Young, one of the king's tutors, on 13 November 1579 (see Hume Brown). The letter refers to portraits of Knox and Buchanan by an unspecified painter (delivered in 'una pyxide') but not to one of the king. Beza was a serious iconographer—when he could not procure an authentic portrait he left the space for it blank—and given the king's importance to a historian of the reformation, the engraving can be assumed to be an attempt at a real portrait. Carlyle describes the engraving as being of 'a half-ridiculous, half-pathetic protecting genius'. The link between Vanson and Beza in the accounts is highly suggestive. See no. 20.

IOANNES CNOXVS.

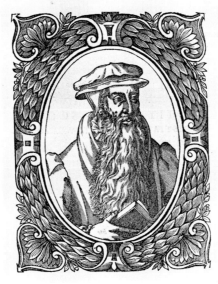

11 John Knox (1505–1572)

Wood engraving: $5\frac{1}{8} \times 4\frac{1}{8}$ (13 × 10.4). From Theodore Beza's *Icones, id est Verae Imagines, Virorum Doctrina simul et Pietate Illvstrium* . . ., Geneva, 1580.

Literature: Carlyle (cited above), pp. 101 ff.; James Drummond, 'Notes upon some Scottish Historical Portraits', *Proceedings of the Society of Antiquaries of Scotland*, vol. xi, 1876, pp. 237 ff.; P. Hume Brown (cited above), pp. 320–4; W. Carruthers, 'On the Genuine and Spurious Portraits of Knox', *The United Free Church Magazine*, May 1906, pp. 16–21; C. Borgeaud, 'Le "Vrai Portrait" de John Knox', *Bulletin de la Société de L'Histoire du Protestantisme Français*, 1935, pp. 5 ff.; Jasper Ridley, *John Knox*, 1968, note under frontispiece and p. 25; Roy Strong, *Tudor & Jacobean Portraits*, 1969, pp. 186–7; Thomson (cited above), pp. 46–7.

Scottish National Portrait Gallery

This is assumed to be after the second of the two portraits by Vanson sent to Beza: if this is correct, like the engraving of the king, it is a reflection, even if rather pale, of Vanson's style. That it is a genuine portrait of Knox has been disputed by Carlyle and Strong: by the former on the curious grounds that Knox could not have looked like this, by the latter on the grounds that Goulard's French edition of 1581 contains a different image for Knox, which is presumed to be a correction. Behind both arguments lies a belief that the payment in the Treasurer's Accounts, because of its date, must be for a portrait done after March 1580 when the *Icones* originally appeared. Given the nature of the accounting procedures, Beza's seriousness as an iconographer, and the bad picture-editing of Goulard's edition,

this conclusion has little substance. Further, as Strong admits, the present engraving agrees closely with Peter Young's verbal description of Knox: 'His face was rather long; his nose of more than ordinary length; the mouth large; the lips full, the upper lip a little thicker than the lower; his beard black mingled with grey, a span and a half length long and moderately thick' (see Hume Brown).

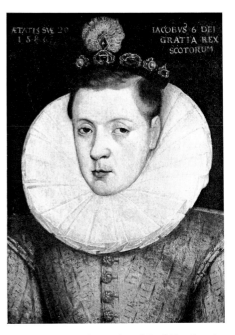

12 James VI of Scotland I of England (1566–1625)

Panel: $23\frac{1}{4} \times 19\frac{3}{8}$ (59.1 × 49.2) Inscribed top right: IACOBVS 6 DEI / GRATIA REX / SCOTORUM; and top left: ÆTATIS SVÆ 20/1586

Provenance: early history unknown.

Exhibition: Edinburgh, Bute House, *Royal Stuart*, 1949, no. 67.

Lent by the National Trust for Scotland, Falkland Palace

Attributed. Apparently an official image of the king, it is difficult to avoid associating it with Vanson in his role of court-painter. Stylistically, it agrees with the 1595 portrait of the king (no. 14). The drawing and handling of paint are not entirely unsophisticated, though rather finicky in manner. The rather hard, unmodified contours of the hair areas are common features. Also similar is the way in which the eyes are hooded by the upper lids, while the irises are placed strangely high on the eyeballs, leaving areas of white between them and the lower lids.

A similar portrait (not exhibited) is that of Patrick, Lord Glamis at Glamis, dated 1583, which may be by the same hand.

13 Sir Thomas Kennedy of Culzean (c. 1549–1602)

Canvas: 79 × 35 (200.7 × 88.9)
Inscribed top right: AVISE A LA FIN [above coat of arms] 1592; and top left: HIS AIGE. / XLIII

Provenance: by descent through the Kennedys of Culzean, the Earls of Cassillis, and the Marquesses of Ailsa.

Lent by the National Trust for Scotland, Culzean Castle

Attributed. The attribution is based on stylistic similarities to the portrait of the king of 1595 (no. 14) which is itself an attribution (the broad basis for which is mentioned above). The method whereby the heads are constructed is the same, basically rather linear, with minimal but just sufficient tonal variation. If the forms of the head and shoulder area are isolated, they are seen to fall into a pattern almost exactly the same as in no. 14: this would have been even more marked if the artist had not changed the contour of the hat, the earlier form of which is just visible to the right of the face. The calligraphy of the date, especially the rather unusual '2', is also close to the forms of no. 14. See also the notes to no. 57.
 Kennedy was knighted at the coronation of Anne of Denmark on 17 May 1590, an event which may have occasioned the portrait. He was murdered on 11 May 1602, those subsequently executed for the murder being his son-in-law James Mure and the latter's father.

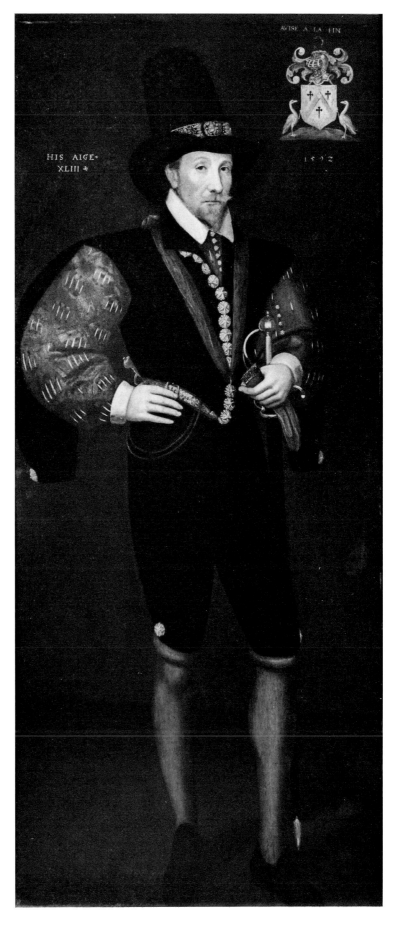

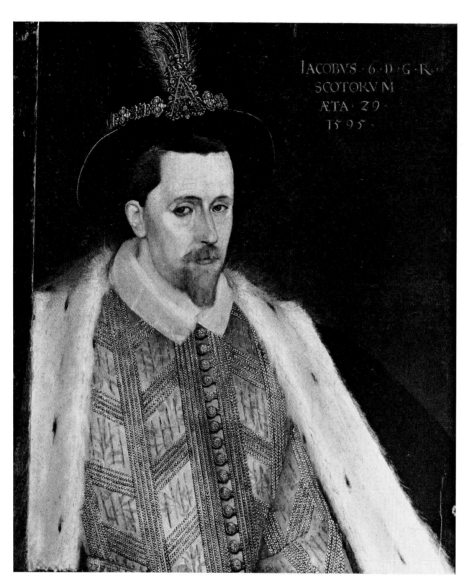

14 James VI of Scotland I of England (1566–1625)

Panel: $28\frac{11}{16} \times 23\frac{5}{8}$ (72.9 × 59.9)
Inscribed top right: IACOBVS . 6 . D . G . R /
SCOTORVM / ÆTA . 29 . / 1595 .

Provenance: early history unknown;
J. Whitford MacKenzie, from whose
effects purchased 1886.

Literature: Strong (cited above), p. 178;
Thomson (cited above), p. 47.

Scottish National Portrait Gallery

Attributed. The attribution follows from
the picture's obvious importance as a
royal image and Vanson's apparent
monopoly of portraiture at the court. The
large 'A' of the jewel worn on the hat
signifies Anne of Denmark. The somewhat
dry, linear manner is enlivened by areas
of surprisingly freely-handled paint—the
ermine, for example, has been scored
with a blunt point, probably the handle

of a brush. Though in European terms
an unsophisticated painting, to a very
considerable degree it reinforces the
accepted reading of the king's personality
—intelligent, cunning, and opportunist.

Recently restored. The painting is on
three boards of unequal width and is
almost certainly cut down from a larger
panel. If the outside boards originally
equalled the centre one, the panel would
be extended by some 6 inches on the left
and $1\frac{1}{4}$ inches on the right. This would
place the head in the exact centre, a
much more comfortable as well as a more
likely position (cf. the portrait of Sir

Thomas Kennedy, no. 13). The top edge
appears to be original and uncut, though
this is not certain—an incomplete hat and
jewel would be surprising. At the bottom
of the panel the king's left arm appears
to turn in towards the centre of his body,
probably in order to grasp a sword hilt.
If the comparison with no. 13 is con-
tinued, the inclusion of similarly placed
hands would add about 11 inches to the
bottom (a complete full-length on vertical
boards would be highly improbable).
These additions produce a panel quite
close to the conventional small half-length
format. See also nos. 18 and 19, below.

15 James VI of Scotland I of England (1566–1625)
16 Anne of Denmark (1574–1619)

Circular panels, including frames:
diameter $6\frac{1}{2}$ (16.5)
James inscribed: IACOBVS 6 . D . G . R /
SCOTORVM / ÆTA . 29 / 1595
Anne inscribed: ANNA . D . G . REG /
SCOTORVM / ÆTA 19 / 1595

Provenance: early history unknown;
bequeathed by A. W. Inglis 1929.

Scottish National Portrait Gallery

Attributed. Clearly related to the larger
picture of the king painted in the same
year (no. 14 above): the inscriptions also
follow the same forms. Though small,
these two portraits are not treated in a
miniature-like technique, but are sur-
prisingly free and spontaneous in their
handling.

Recently restored. The picture areas
and frames are turned from single pieces
of wood. The frames are not identical in
section but turned in such a way that one
fixes closely into the other. It is thus
possible that they were formerly hinged
and so capable of being closed to form a
box—when referring to the portraits of
Knox and Buchanan as being in a pyxis,
Peter Young may have intended some-
thing of this sort.

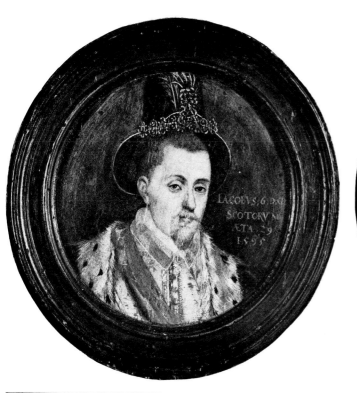

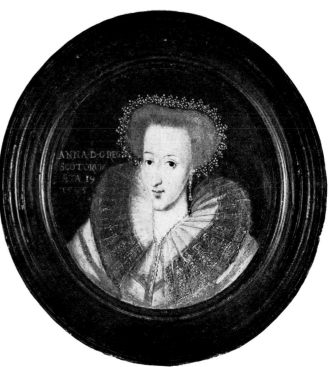

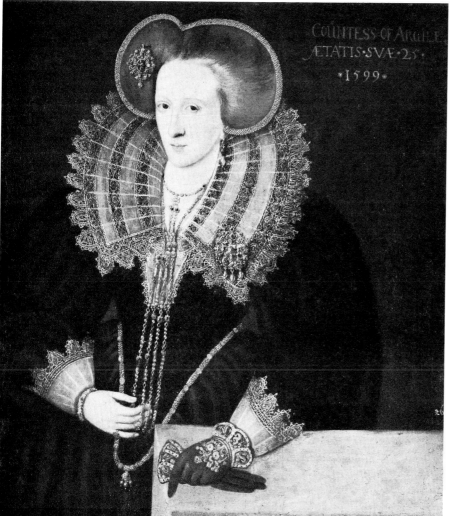

17 Agnes Douglas, Countess of Argyll (c. 1574–1607)

Canvas: 34 × 30½ (86.3 × 77.5)
Inscribed top right: COUNTESS OF ARGILE
[later]/ÆTATIS.SVÆ.25./.1599.

Provenance: with the Marquesses of
Lothian at Newbattle Abbey (probably
from the late seventeenth century);
bequeathed by the 11th Marquess 1941.

Literature: Thomson (cited above), p. 47.

Scottish National Portrait Gallery

Attributed. The hooding of the eyes and
the oblique placing of the irises seem
characteristic of the group of paintings
suggested for Vanson. The rather flat,
somewhat eccentric relation of the
different parts of the figure within the
picture area seem also to be features of
the Flemish-Scottish style—the space-
filling, distorted table-top, abruptly
broken by the hand and gloves, is very
reminiscent of the table in Bronckorst's
Morton (no. 9). The outlines and placing
of the very subdued tones on the face are
paralleled by those in no. 16. Gold-leaf
has been used in the jewels on the hair,
breast, right wrist, and on the gloves.
 The sitter, daughter of the 5th Earl of
Morton, married the soldier and states-
man the 7th Earl of Argyll in 1592. The
earl became a privy councillor in 1598
and was part of the king's retinue when
he left Scotland in 1603. Sir William
Alexander, who had been the earl's tutor,
dedicated his poem *Aurora* to the
countess in 1604.

Related Engravings

IACOBVS. VI REX SCOTORVM .

IACOBVS VI. SCOTIÆ REX, ET PRIMVS EO NOMINE ANGLIÆ
FRANCIÆ, ET HIBERNIÆ MAXIMO APPLAVSV ELECTVS REX &c.
Ampliss. et optimé de rep. merito D.Philippo d'Ayala. e Syndico Antverp. ad Finantiarum Consilium
assumpto. et pro Ser. Belgii Principibus, ad Galliæ Regem Legato præstantissimo. 'P. de Iode Antverp.DD.

18 James VI of Scotland I of England (1566–1625)

Engraving: $6\frac{9}{16} \times 5$ (16.6 × 12.7). From John Jonston's *Inscriptiones Historicae Regum Scotorum*, Amsterdam, 1602.

Literature: A. M. Hind, *Engraving in England . . .*, Part II, 1955, pp. 49–50.

Scottish National Portrait Gallery

Appears to be very loosely derived from no. 14. The hands are resting on a cushion.

19 James VI of Scotland I of England (1566–1625)

Engraving: $7\frac{1}{8} \times 5\frac{3}{4}$ (18.1 × 14.6). By P. de Jode, Antwerp, 1603.

Scottish National Portrait Gallery

Though there are differences in detail, this engraving seems directly related to no. 14, even to the extent of repeating the distorted perspective which places the figure below eye-level while the eyes in isolation are drawn as though above eye-level. It is curious that an image produced eight years earlier should still serve after the accession to the English throne (and be available in Antwerp for engraving). It presumably fills the hiatus between the purely Scottish portraits and the quite different image engraved by Laurence Johnson in the same year (Hind, cited above, p. 35), which in turn was superseded by the de Critz images of 1604. However, the present image (with extensions to the beard and moustache) was used once more in 1604 in *Regiae Anglicae Maiestatis Pictura* (Hind, cited above, p. 40).

Related Coins

20 Twenty Pound piece of James VI (1566–1625)

Diameter $1\frac{5}{8}$ (4.1); value £20 Scots; dated 1575

Literature: R. W. Cochran-Patrick, *Records of the Coinage of Scotland*, 1876, vol. i, pp. 142–5; Edward Burns, *The Coinage of Scotland*, 1887, vol. ii, pp. 384–6; A. B. Richardson, *Catalogue of the Scottish Coins in the National Museum of Antiquities*, Edinburgh, 1901, p. 258 (no. 86), fig. 136; J. H. Stewart, *The Scottish Coinage*, 1967, p. 92.

Lent by the National Museum of Antiquities of Scotland

21 Thirty Shilling piece of James VI (1566–1625)

Diameter 1½ (3.8); value 30 shillings; dated 1584

Literature: Cochran-Patrick (cited above), vol. i, p. 248; Burns (cited above), pp. 368–9 (no. 5); Stewart (cited above), p. 94.

Lent by the National Museum of Antiquities of Scotland

An act of the Privy Council of 14 April 1582 directed that the 40s., 30s., and 20s. pieces should follow the patterns of the 10s. piece, as ordered by an act of Parliament of 24 October 1581, which had 'on the ane syde the portratour of his maiesties body, armit, with ane croun vpoun his heid, and ane suord in his hand, . . .' (*The Register of the Privy Council of Scotland*, vol. iii, 1880, p. 481; *The Acts of the Parliaments of Scotland*, vol. iii, 1814, p. 215). This must be the 'new cunze', or new coinage, which is referred to in the Treasurer's Accounts in January and February 1582—the first reference being a payment of £10 to 'my lord Seytonis painter for certane picturis of his majesties visage drawin be him and gevin to the sinkare to be gravin in the new cunze'; the second, a payment of £100 to 'Thomas Fowlis, goldsmyth, for sinking of the new irnis [irons] to his hienes new cunze . . .' (SRO, E 21/62, fos. 169v., 180).

The portrait is close to that on the £20 piece (no. 20), the principal differences being the replacement of the figure-of-eight collar by a wheel ruff and the addition of decorations to the armour. It is likely, therefore, that the same painter provided the images, and given the link between the portrait of the king in Beza's *Icones* and the earlier coin, it seems possible that Lord Seton's painter is, in fact, Vanson—it would be entirely in keeping with Seton's career that he should introduce a painter from abroad. It would thus be a natural progression for Vanson to become painter at the court when Arnold Bronckorst departed before the end of 1583.

22 Hat-piece of James VI (1566–1625)

Diameter 1⅛ (2.9); value £4 Scots; dated 1592

Literature: Burns (cited above), pp. 393–4 (no. 2); Stewart (cited above), pp. 95–6.

Lent by the National Museum of Antiquities of Scotland

An act of Parliament of 6 August 1591 referring to this series of coins, dating from 1591, describes them as 'havand [having] on the ane syde his hienes portrat according to the painteris draucht . . .' (*The Acts of the Parliaments of Scotland*, vol. iii, 1814, p. 526). They are distinguished by the informal hat worn by the king. Although the image is profile it seems the immediate ancestor of the 1595 portrait of the king which has been attributed to Vanson (no. 14): in the king's iconography it fills the gap between the beardless young man of 1586 (no. 12) and the maturely bearded man of the later portrait.

This coin belongs to the earliest gold issues of James VI. A related contract is between the regent, the Earl of Morton, and John Achesoun, master coiner, and Abraham Petersoun, refiner.

The portrait image is so close to the wood engraving of the king in Beza's *Icones* (no. 10) that both must stem from the same original portrait. If it is correct that the print in Beza was based on a portrait by Vanson then it would appear that he was employed on work for the coinage as early as *c.* 1574/5, which is five or six years before the earliest record of him in Scotland. The possibility that Vanson at this time was known as Lord Seton's painter is discussed at no. 21 below.

Portrait of Lord Seton

23 George Seton, 5th Lord Seton
(c. 1533–1585)

Panel: $47\frac{1}{4} \times 41\frac{5}{8}$ (120 × 105.7)
Inscribed above left shoulder: ÆTATIS
SVÆ 27; inscribed on the plinth on the
right: *In adversit[ate] / patiente / In
prosperit[ate] benevole[nte] / Hasard z[et] /
forduer[d] / 157[?]*; name and arms top
left are probably later

Provenance: perhaps in the possession of
Hugh, 7th Lord Somerville (a privy
councillor to James VI and I) during the
sitter's lifetime: Lord Somerville was the
sitter's brother-in-law; certainly in the
possession of James, 13th Lord Somer-
ville by 1757; by descent to Hugh, 18th
Lord Somerville, and thence to his coheir
Mary Somerville who married Sir
Theophilus Biddulph, 7th baronet; be-
queathed by Sir Theophilus Biddulph,
8th baronet, 1965. (A similar picture at
Pinkie House (Tweeddale, ex-Dunferm-
line collections) was a different size,
$24\frac{1}{2} \times 19\frac{1}{2}$ inches.)

Exhibition: Royal Academy, *British
Portraits*, 1956/7, no. 24.

Literature: Alexander Nisbet, *A System
of Heraldry*, 1816 (first published 1722),
vol. i, p. 234; David Piper, *Apollo*,
December 1956, p. 196; catalogue of the
National Gallery of Scotland, 1970
edition, pp. 33–4.

National Gallery of Scotland

The picture has been cut down on the
right so that the last digit of the date has
been lost. Lord Seton's date of birth is an
important factor in unravelling the many
problems which beset an understanding
of this picture; this has traditionally been
accepted as 1530 but the portrait of the
same subject with members of his family
by Frans Pourbus dated 1572 (National
Gallery of Scotland) gives his age as 39
and thus establishes the year as being
c. 1533: this seems reliable evidence. His
age in the present portrait is 27, which
ought to date the picture about 1560.
Even allowing for a few years' error, this
would produce a date nowhere near 1570.
One solution (RA, catalogue) has been to
suggest that the date should really be
read as 1557, one of the years in which
Seton visited France: this seems far

fetched for a number of reasons, one being that Seton, who carries the baton of Master of Mary, Queen of Scots' household, did not receive that office until 1560/1. The picture, however, almost certainly commemorates the grant of that office and a likely explanation is that the picture was painted in the 1570s (perhaps in 1579 when Seton, a catholic and long discredited, was readmitted to the favour of James VI) to recall Seton's days of former glory. This view seems supported by the nostalgic note of the inscription—'in adversity, unyielding, in prosperity, generous'. (These arguments would fall, however, if it were proved, which seems unlikely, that the inscription and date were simply added to an older portrait in the 1570s.)

One other factor which supports the explanation that the portrait is of the 1570s and is retrospective is that the pattern of the head is close to that in the Pourbus portrait of 1572. This is perhaps not surprising since it is the same man, but the similarity extends to minute details and areas of tone—the only differences being a smoothing out of lines and removal of hair from the face. The Pourbus portrait thus probably served as a model for the present portrait.

Though Seton visited France during the 1570s there seems no reason to believe that the picture is French. He was also in the southern Netherlands in 1570, which is rather more suggestive. The type is a northern, rather peripheral variation of the mannerist portrait with a highly charged inscription on a fragment of architecture, associated with painters like G. B. Moroni: the type is found in England in the late 1540s and early 1550s in the work of the Netherlander, Guillim Scrotes, in paintings that are sometimes commemorative. The picture, however, despite its obvious splendour, ultimately lacks a little in sophistication and it may be that it should be seen as the finest surviving product of the Anglo/Scoto-Netherlandish style of Bronckorst and Vanson. One aspect of this latent *naïveté* is the impossible relationship of the notional position of Seton's feet, the base of the plinth, and the foot of the table on the left which bears the armour. Another is the drawing of the face which is not very far removed from the painting of the king of 1595 (no. 14), features rather eccentrically related and the perspective ambivalent (see notes to no. 19). Further, it should be noted that Seton had in his employ in January 1582 a painter of sufficient skill to be entrusted with providing designs for the king's portrait in the new coinage. It is conceivable that 'my lord Seytonis painter' and Adrian Vanson were the same person (see notes to no. 21).

The Seton Armorial, 1591

24 James III (1457–1488) and Margaret of Denmark (c. 1457–1486) from the Seton Armorial

Gouache: $9\frac{13}{16} \times 6\frac{1}{2}$ (25 × 16.5)
Inscribed top right: James the Thrid / Began his Raigne / 1460. He maryed / Margaret dochter to / Christian King of Denmark

Literature: Sir Thomas Innes, *Scots Heraldry*, 1956, pp. 75–6.

Lent by Sir David Ogilvy

An inscription on the title-page indicates that this armorial was made for Robert, Lord Seton, in 1591. The first 38 folios contain 17 full-length paintings of Scottish monarchs, some with their queens, and one showing the 'Habit of a Herald'. They are quite crude but colourful. The most interesting of the earlier ones is that of Kenneth II, 'who overcame the Picts': he is shown with sword and shield astride two Pictish princes who are boldly foreshortened in a way suggestive of some knowledge of the way the sleeping soldiers might be depicted in a Flemish *Resurrection*. Behind him is a rudimentary, perhaps unfinished, townscape.

The Jameses (James I is missing) with their queens are the standard images; also included are a rather pathetic, armoured Darnley with Mary, Queen of Scots, and a beardless James VI with Anne of Denmark. The portrait of James III (at which the armorial is open) is part of that remarkably long chain stretching from the likeness in the Trinity altarpiece and the groat of c. 1485 (no. 74) to Jamesone's painting of 1633 (no. 64).

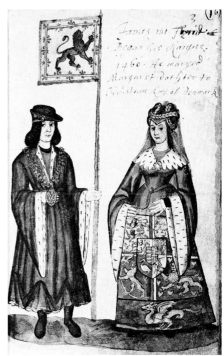

Works by Unidentified Painters 1592-1623

25 The Memorial of James Stewart, 2nd Earl of Moray (c. 1568–1592)

Canvas: 29 × 87 (73.7 × 221)
Inscribed along the top (in gold-leaf):
1591 / FEBR . 7 / GOD REVENGE MY CAVS . / ÆTA . 24 .

Provenance: family ownership since painted (but see below).

Exhibition: Edinburgh, Bute House, *Royal Stuart*, 1949, no. 25.

Literature: David Calderwood, *The History of the Kirk of Scotland*, vol. v, 1844, pp. 144–5; Ellis Waterhouse, *Painting in Britain 1530 to 1790*, 1962, p. 29.

Lent by the Earl of Moray

This painting belongs to the same, peculiarly Scottish, genre as the *Memorial of Lord Darnley* (no. 1). Like that painting it is a strident call for revenge but formally it is the exact antithesis. In the earlier picture the horrific sentiments are cloaked in verbal niceties and the calm, subtle forms of the religious donor picture: here the message is startlingly immediate, clear, and brutal.

James Stewart (traditionally referred to as the 'bonnie Earl') married the eldest daughter of the Regent Moray in 1580 and assumed the title in his wife's right. The Earl of Huntly, in the pursuit of a traditional feud against the ultra-protestant Moray, was granted a commission to detain him because of alleged contacts with Bothwell. At this time Huntly, though later suspected of catholicism, was very much in favour with the king. The historian Calderwood (writing earlier than 1648) states that on the night of 7 February Huntly 'went out of Edinburgh from the king, and the same night sett the hous of Dinnybrissill [Donibristle, near Aberdour] on fire, so that the Erle of Murrey was forced to come furth, and was discovered by some sparkes of fire in his knapskall [nightcap], and so was killed and cruellie demained.'

Calderwood's account further states that on 9 February Moray's mother had his body carried to Leith and thence to Edinburgh with the intention of making a public spectacle of it. However, this was forbidden by the king (whom Calderwood clearly believed was guilty of complicity in the murder). Apparently because of this prohibition Moray's mother 'caused draw her sonne's picture, as he was demained, and presented it to the king in a fyne lane cloath, with lamentatiouns, and earnest sute for justice. But little regard was had to the matter. Of the three bullets she found in the bowelling of the bodie of her sonne, she presented one to the king, another to [blank] the thrid she reserved to herself, and said, "I sall not part with this, till it be bestowed on him that hindereth justice." '

The detail of this commentary seems entirely credible—besides the sword wounds there are clearly bullet wounds in the lower part of the torso—and it can probably be assumed that the painting was done in Edinburgh as is implied. It is the work of a decorative or heraldic painter and seems to owe nothing to any kind of sophisticated pictorial tradition—Waterhouse has said that the 'formal qualities of this painting are superior in energy and realism to the contemporary English costume piece'. The principal decorative painters who were employed at court in these years were Walter Binning and James and John Workman (though Vanson also on occasion did work of this sort the painting cannot possibly be connected with the tradition he represented). Besides painting interiors, furniture, and banners, much effort was expended on creating armorials of forfeited nobles which were ceremonially destroyed. For example, in June 1594 James Workman was paid £4 'for making twelf armes of the foirfaltit lordis to be revin in the tolbuth and at the croce of Edinburgh' (SRO, Accounts of the Treasurer of Scotland, E 21/70, fo. 112). However, a document which may be more significant is a contract of 25 April 1592 between those responsible for Moray's burial and John Workman (who was licensed as a herald painter in November of the same year) to make and deliver the 'ceremonies and furnitour' for the funeral (SRO, Register of Deeds, vol. xliii, p. 104). In these circumstances it would not be unreasonable to attribute the present painting to Workman, at least on a speculative basis. Workman died of the pest on 31 October 1604 (*Edinburgh Register of Testaments*, Part II, 1898, p. 441).

There is one precedent for this painting and that, surprisingly, is found in the *Memorial of Lord Darnley* (no. 1) where, it has already been noted, the confederate lords at Carberry carried a banner showing Darnley's body and bearing a similar inscription.

There is also a sequel, a record by an unknown writer of a burial in July 1595 consequent on the murder of a man called Forester in a factional feud (*The Historie and Life of King James the Sext 1566 to 1596*, edited T. Thomson, 1825, pp. 346–7). In this case the Earl of Mar, whose servant the slain man had been, 'cawsit mak the picture of the defunct on a fayre cammes [canvas], payntit with the number of the shots and wounds, to appeare the mair horrible and rewthfull to the behalders . . .' Somewhat surprisingly, the author also says that 'this forme is rare, and was never usit in Scotland before', a remark which cannot be strictly true.

Colour illustration

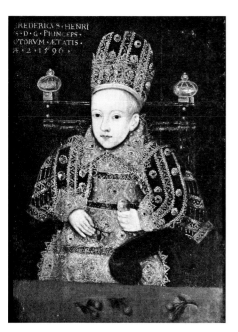

26 Prince Henry Frederick (1594–1612)

Panel: 27 × 20½ (68.6 × 52.1)
Inscribed top left: HREDERICVS [*sic*].
HENRI / CVS . D . G . PRINCEPS . / SCOTORVM .
ÆTATIS . / SVÆ . 2 . 1596 .

Provenance: early history untraced.

Lent by the Earl of Rosebery

The Treasurer's Accounts appear to
indicate that Adrian Vanson was the only
painter at court to produce portraits
during the last decade of the sixteenth
century but the present picture is clearly
an exception. The handling of paint and
the drawing, as indeed the whole con-
ception, are decidedly primitive, and
point towards the heraldic or decorative
painters. Though it is difficult to define
the stylistic characteristics of pictures of
this sort, there appears to be some
similarity between the structure of the
faces in this portrait and in the *Memorial
of Lord Moray* (no. 25)—a rather smooth
outline, little tonal variation, and a nose
flattened into near-profile. As already
noted (no. 25), those working at court in
these years were Walter Binning and
James and John Workman. If not by one
of these, then the author may be looked
for among the quite large number of
painters who are recorded in Edinburgh
at this time: Thomas Binning, John
Sawers, William Cockie, William
Symington, and Laurence Shorthouse (all
mentioned between 1595–1603 in
(GRO(S), Old Parochial Registers,
Edinburgh, vol. i).
 The prince, after showing great
promise as a youth, died prematurely at
the age of eighteen in 1612.

27 Sir Duncan Campbell of Glenorchy (c. 1554–1631)

Panel: 44 × 28 (111.7 × 71.1)
Coat of arms top right with initials S/DC
and the date 1601

Provenance: family ownership since
painted.

Literature: *The Black Book of Taymouth*,
edited Cosmo Innes, 1855, pp. iv–vi.

Lent by Armorer, Countess of Breadalbane

The sitter was father of Sir Colin
Campbell of Glenorchy, who was to be
the principal patron of George Jamesone
in the middle and late 1630s and who

36

filled his houses of Balloch and Finlarg
with large numbers of family and royal
portraits. A volume of inventories of
Balloch and Finlarg for the years 1598–
1610 (SRO, GD 112/22/4) lists what
appears to be the only painting in Sir
Duncan's possession during these years:
'Off brodis quhairin [wherein] the Lairds
pictur is —— i'. It first appears in 1603
and is almost certainly the present
portrait. Nevertheless, the Black Book of
Taymouth (see no. 58) suggests that he
had some interest in the arts of civiliza-
tion, for it states that 'in his tyme [he]
biggit [built] the castell of Finlarg, pitt,
and office houss thairoff, repairit also the
chapell thairoff, and decored the same
inwardlie with pavement and paintrie'.
The house and chapel were ultimately
destroyed in 1695, 'the chapel being
fynly painted with curious painting
totallie torne doune . . .' (SRO, GD
112/22/4, sheet dated 28 February 1695).
Sir Duncan also owned a number of
books and initiated the compilation of the
Black Book in 1598. He added a second
picture to his collection in 1619, another
portrait of himself by a very different
kind of painter (no. 32).

Though Campbell travelled to the
continent, the picture is not likely to have
been painted there. It has a good deal in
common with the portrait of Sir Thomas
Kennedy (no. 13) and the 1595 portrait
of the king (no. 14), which are here
attributed to Adrian Vanson. The some-
what forbidding, rather oblique cast of
the features, the unmodulated line of the
hair, the slightly gauche drawing of the
collar, are close to the same features in
the portrait of the king.

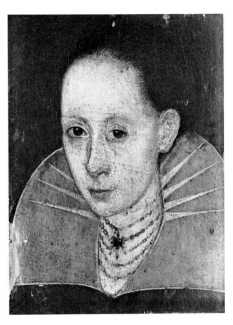

30 Unidentified Girl

Panel: 13 × 10 (33 × 25.4)

Provenance: probably by descent through
Sir Patrick Hamilton of Little Preston
(son of no. 29) who married Elizabeth
Macgill, daughter of the 1st Viscount
Oxfurd; their grandson, Thomas
Hamilton Macgill, succeeded to the
Oxenfoord property in 1758; the latter's
daughter and heir married her cousin Sir
John Dalrymple, ancestor of the present
owner.
Literature: Horace Walpole, *Anecdotes of
Painting in England*, 1876, vol. i, p. 349
(confused with Jamesone); Sir Hew
Dalrymple, *Pictures at Oxenfoord Castle*,
1911 (privately printed), nos. 96, 78, and
80; D. Thomson, *The Life and Art of
George Jamesone*, 1974, pp. 48, 92.

Lent by the Earl of Stair

These three small portraits are almost
certainly fragments of larger paintings
which originally measured about 36 × 24
inches and showed three-quarter length
figures. Copies showing the original
format are still at Oxenfoord (Dalrymple,
nos. 18, 21, and 20 respectively). The
copies of nos. 29 and 30 above are
inscribed: *Ætatis Suæ 32*/1612/M P H/
[Master Patrick Hamilton] and *Ætatis
Suæ 14*/1612. It seems reasonable, there-
fore, to assume that all three original
fragments were painted in 1612. Two
other three-quarter lengths at Oxenfoord
(Dalrymple, nos. 19 and 23) of a man
(his age 57) and a woman (her age 32) are
also dated 1612 and may be contemporary
with the fragments (their condition makes
their status difficult to assess). In any case,
the three exhibited cut-down portraits
were clearly originally part of a set of at
least five three-quarter lengths.
No. 28 is traditionally identified as

**28 Thomas Hamilton of Priestfield
(probable identity; born *ante* 1549)**

Panel: 13¾ × 9¾ (35 × 24.7)

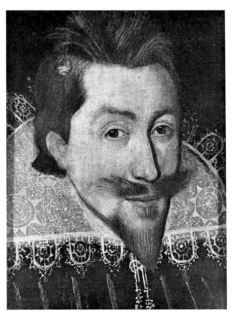

**29 Sir Patrick Hamilton of Little
Preston (1580–1659)**

Panel: 12½ × 9½ (31.7 × 24.1)

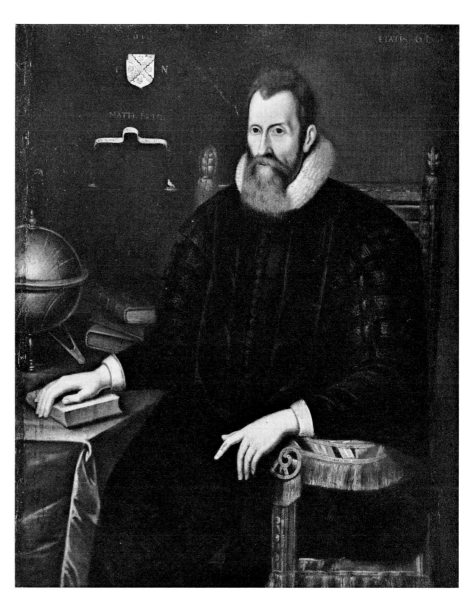

Thomas Hamilton, later 1st Earl of Haddington (born 1563). The considerable age of the sitter, however, makes this clearly impossible. The identity of no. 29 is, given the inscription, reasonably sure. Patrick Hamilton was the younger half-brother of Thomas and it therefore seems not improbable that there is an element of truth in the traditional identification of no. 28 and that it represents the father of these two, Thomas Hamilton of Priestfield who is recorded as under age in 1549 (see Sir William Fraser, *Memorials of the Earls of Haddington*, 1889, vol. i, p. 377).

These three heads should perhaps be classified as representing a provincial continuation of the manner associated with Vanson who, it has been noted, was encouraged to train apprentices. Formally they are a later variant of the type of portrait represented by the 1596 portrait of Prince Henry (no. 26). A quite instructive comparison can also be made between the *Thomas Hamilton* and Bronckorst's *Baron St John of Bletso* (no. 7). The *Bletso* has an understanding of both bone structure and how flesh can be suggested by the slightest modulation of tone, while no. 28 implies a painter using a purely empirical approach to the problems presented by a face: the thick, interlocking lines of pigment represent a simple exploration with no sense of any underlying formal unity—though an image with some power to move does result.

As a group, these pictures are a revealing commentary on the state of painting in Scotland in the decade after the departure of the court and, more precisely, in the very same year in which the decorative painter John Anderson took George Jamesone as an apprentice in Edinburgh.

31 John Napier of Merchiston (1550–1617)

Canvas: $47\frac{1}{2} \times 39\frac{1}{2}$ (120.6 × 100.3) Coat of arms top left with date and initials: 1616 / IN; below this: MATH . 10 . 10 ('the workman is worthy of his meat'); inscribed top right: ÆTATIS . 66.

Provenance: by descent to Margaret, Baroness Napier (d. 1706), who gave it to the University of Edinburgh.

Literature: Mark Napier, *Memoirs of John Napier of Merchiston*, 1834, pp. ix–x; D. Talbot Rice and P. McIntyre, *The University Portraits* [Edinburgh], 1957, no. 101.

Lent by the University of Edinburgh

Like the portrait of Sir Duncan Campbell of 1619 (no. 32), this is an interesting, though quite different, glimpse of painting in Scotland prior to Jamesone. The conception is far more varied, the treatment more traditional, with traces of

northern mannerism in the tonal values, but there is a good deal of awkwardness in the drawing, notably the 'incorrect' perspective of the chair. The portrait type can be traced back ultimately to Raphael's *Julius II* (London, National Gallery): the subject is seated at an angle to the picture plane, the hands are deployed as an extension of the personality, the eyes are fixed beyond the spectator, and the head is sunk in contemplation of the verities, presumably in Napier's case the numerative ones. The only other Scottish portrait of this type in our period appears to be Jamesone's *Sir Thomas Hope* of 1627 (Thomson, no. 18). This is one reason why it is tempting to speculate that the present portrait might be the work of Jamesone's master John Anderson, who was certainly in Edinburgh a good deal when this portrait was painted. Anderson's only significant surviving work is the decoration of the small room in Edinburgh Castle in which James VI was born. This includes a large coat of

arms with two especially lively unicorns, the smooth gradations of tone on their bodies being not unlike the tonal treatment of Napier's head and especially his hands. This is a tenuous link: but, given Anderson's relationship to Jamesone, it seems inconceivable that he did not on occasion tackle portraiture (see notes on John Anderson on page 49).

Napier wrote his *Mirifici Logarithmorum Canonis Constructio* ('The Construction of the Wonderful Canon of Logarithms') in 1614 but it was not published until 1619. His pursuits in his earlier years have a Leonardesque ring: a hydraulic screw for raising water from mines, a burning mirror for destroying ships from the land, artillery, tanks, and submarines. He also invented the earliest calculating machine, 'Napier's Bones'. He was, however, best known in his lifetime for his book, *A Plaine Discovery of the Whole Revelation of St John*, which, published in 1593, went through a large number of editions in many languages.

32 Sir Duncan Campbell of Glenorchy (c. 1554–1631)

Canvas: $34\frac{7}{8} \times 27\frac{7}{8}$ (88.5 × 70.8)
Coat of arms top left with initials s/DC
and the date 1619; inscribed top right:
Sir Duncan Campbell | Ætatis Suæ 65.7 / 7
(apparently over older inscription)

Provenance: family ownership until sold
at the Invereil House sale, 3 March 1969.

Literature: *The Black Book of Taymouth*
(cited above), p. vii; D. Thomson, *The
Life and Art of George Jamesone*, 1974,
p. 53.

Scottish National Portrait Gallery

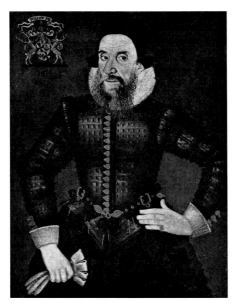

This is a very different kind of image
from the 1601 portrait of the same man
(no. 27), and one which seems more in
keeping with what is known about certain
barbaric aspects of his behaviour,
especially with regard to the MacGregor
family. The sheer roughness of technique,
the near-heraldic use of colour in the face,
the firm patterning of the picture area,
add up to a portrait of primitive vigour.
Any subtleties left by the Netherlandish
court painters, whose work by comparison
seems part of the European mainstream,
have entirely vanished. It is an interesting
view of portraiture in Scotland in the
year before Jamesone's independent
career began. The painting may represent
the work of one of the native decorative
painters of the period—and the significant
name of John Anderson, Jamesone's

master, still seeks a portrait *œuvre*—but it
should not necessarily be assumed that
because of its formal crudity it is a native
product. In the 1630s the sitter's son em-
ployed the so-called 'German painter'
(see notes to no. 58 below) who produced
images of his ancestors of even greater
crudity. They were not from life as the
present portrait undoubtedly is, which
gives it a certain edge in concreteness. It
should not be entirely discounted that the
present portrait was painted by that
painter on an earlier visit or by someone
from the same circle.

33 Unidentified Man, aged 57

Panel: 37 × 28 (94 × 71.1)
Inscribed at top: $Æ^T$ $SVÆ$ 57 .AN^O .1623

Provenance: probably by descent from the
Gordons of Haddo to the Earls and
Marquesses of Aberdeen (and Temair).

*Lent by the Executors of the late
Marquess of Aberdeen and Temair*

The traditional identification as James VI
and I, presumably derived from the
coincidence of the inscription, should be
discounted. Assuming that the picture has
always been in family possession, the
sitter seems likely to be James Gordon of
Haddo who married a sister of the 5th
Earl Marischal after a contract of 25 July
1582 and died in November 1623.
 The style of this unsophisticated but
bold portrait does not connect with any
other known portraits of the period. The
likely provenance of the picture suggests
that it should be connected with north-
east Scotland and the decorative painters
of Aberdeen with whom Jamesone had,
and retained, close links. The high tonal
key and the very linear handling of pig-
ment, the brushstrokes never quite merg-
ing, are not unlike some provincial

Scandinavian painting. This linearity
means that the eyes tend to be over-
worked and do not quite take their place
within the unity of the face: this is a
common feature in the figural parts of the
work of the decorative painters. Viewed
from another aspect this picture may also
be seen as a continuation of the more
peripheral, native tradition represented
by the three portraits from Oxenfoord of
1612 which have the same high key and
linear use of thickish pigment (see nos.
28–30).
 Apart from John Anderson, who is
treated separately below, the principal
decorative painters in the north-east were
as follows:

JOHN MELLIN (or MELVILLE)
flourished 1587–1604

Painted imitation tapestry at the rear of
the rood loft of St Nicholas Church,
Aberdeen, in July 1587; also painted the
east clock on the church (City of
Aberdeen Records, Kirk & Bridge Works
Accounts 1571–1670, under 3 July 1587).
The painted ceilings at Delgatie Castle,
near Turiff (heraldic devices, arabesques,
elephant, sphinxes), are signed 'JM' and
dated 1592 (or 3) and 1597: they are

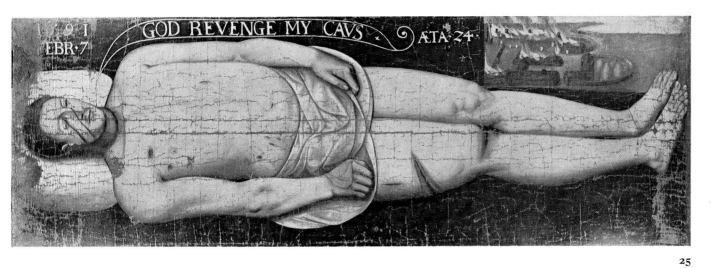

25

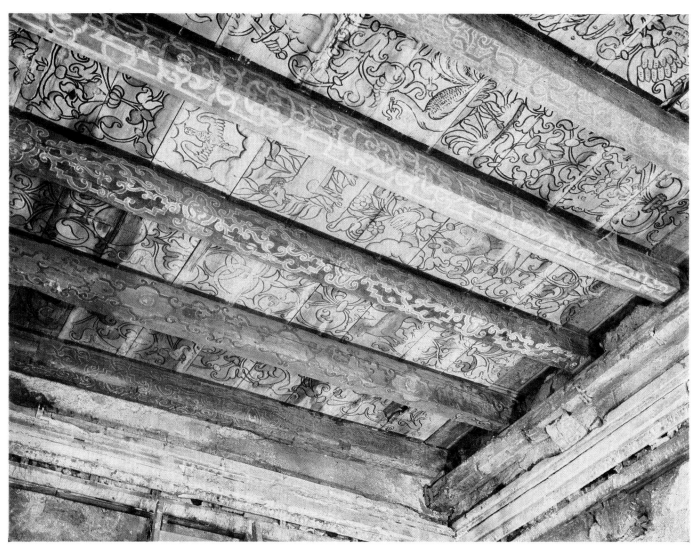

35

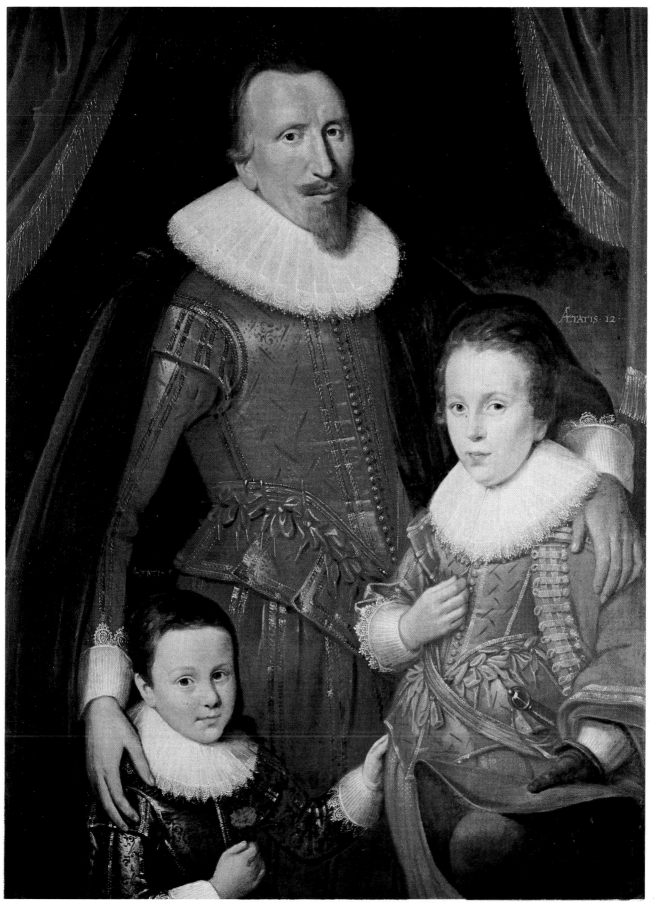

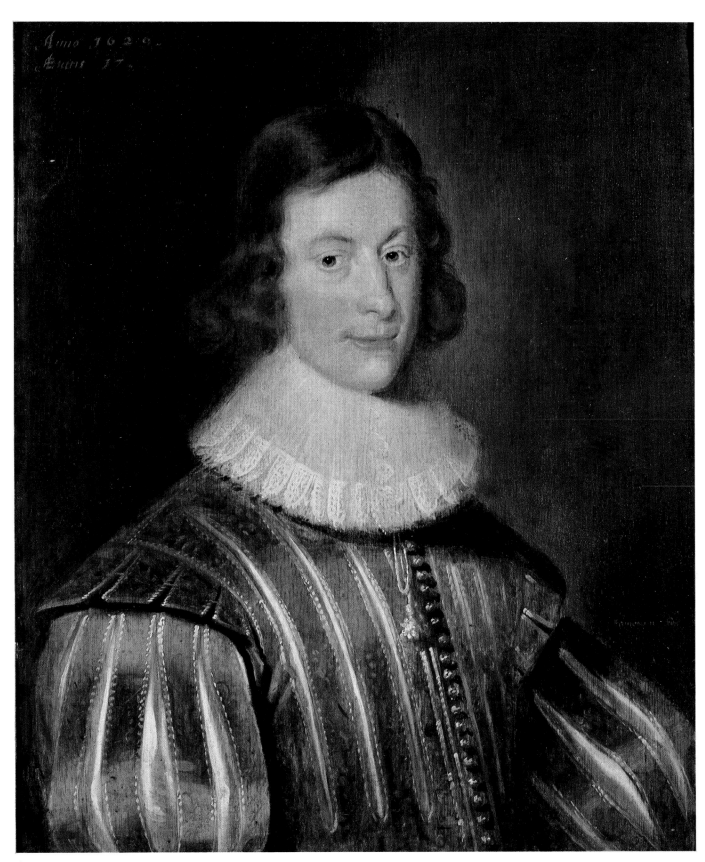

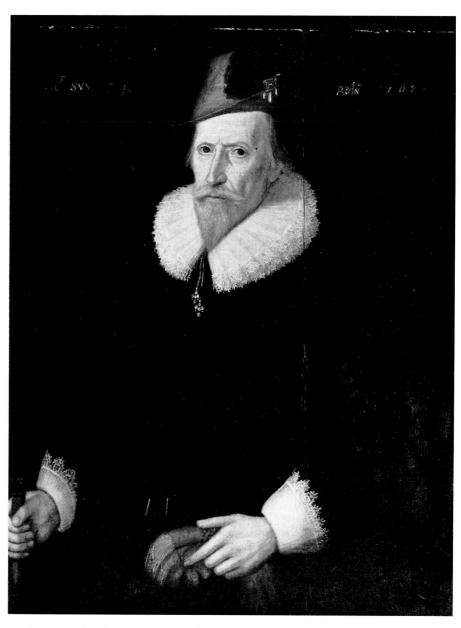

perhaps, therefore, by John Mellin. In 1604 he was accused by the church-session 'for paynting of a crucifix to the Buriall of the Ladye of Gicht [Isobel Auchterlony, Lady Gordon of Gight] quhilk [which] wes borne at hir buriall . . .' (SRO, Aberdeen Kirk-Session Records, CH 2/448/2, under 13 May 1604).

ANDREW MELLIN (or MELVILLE)
flourished 1611–1613

Painted 'the new beir' in St Nicholas Church in 1611 (AR, Kirk & Bridge Works Accounts 1571–1670); married an Isobel Jamesone on 21 January 1613 (GRO(S), Old Parochial Registers, Aberdeen, vol. vii, under date). A Thomas Mellin was godfather to George Jamesone's daughter Mary in July 1644 (ibid., vol. iii).

ANDREW STRACHAN
d. 1673

Had a daughter, Violet, by his wife, Margaret Mellin, on 29 April 1617, and a son, Robert, on 22 September 1619; a son, Thomas, with George Jamesone as

godfather was baptized on 27 December 1628; a daughter, Esther, was baptized on January 1632 (GRO(S), OPR, Aberdeen, vol. ii, under dates). On 27 October 1630 he was one of seven godfathers at the baptism of George Jamesone's son Paul (ibid.); while, on 29 October 1633, he witnessed instruments of sasine in favour of Jamesone and his wife Isobel Tosche (SRO, Particular Register of Sasines, Aberdeen, vol. 8, fos. 367v.–371v.). On 17 September 1642 he was paid £5 6s. 8d. for illuminating the name and arms of Sir Alexander Hay on the Bridge of Don, and in the same year was paid £12 for varnishing three pulpits and the rood loft in the New Church of St Nicholas. The following year he was paid £6 13s. 4d. for painting two sundials and Aberdeen's arms on the exterior of the same church (AR, Kirk & Bridge Works Accounts 1571–1670). On 13 February 1645 he and his wife disposed of property

in Aberdeen (AR, Register of Sasines, vol. xl, under date). His wife was buried on 5 May 1662, while his own burial is recorded on 14 February 1673 (GRO(S), OPR, Aberdeen, vol. xviii, under dates).

Processional Roll for a Scottish Armorial Funeral

34 Funeral Procession Traditionally Linked with the Obsequies of George, 1st Marquess of Huntly (d. 1636)

Water-colour and ink on 17 sheets of paper: overall length 16 ft. 6⅛ in. (5.034 m.); maximum height 8⅛ in. (20.7 cm.), minimum height 5⅞ in. (14.9 cm.)

Provenance: David Laing, by whom given to the Society of Antiquaries.

Literature: *Proceedings of the Society of Antiquaries of Scotland*, vol. x, pp. 245, 309; Thomas Innes, 'Processional Roll of a Scottish Armorial Funeral, . . .', *P.S.A.S.*, vol. lxxvii, 1943, pp. 154–73.

Lent by the National Museum of Antiquities of Scotland

The Lord Lyon's examination of the heraldry displayed has shown that the escutcheons are imaginary and often wrongly related and that the roll cannot, therefore, be connected with any particular funeral. His conclusion is that the roll was simply used as a guide for marshalling those who would form the funeral procession at the burial of any Scottish nobleman in the early seventeenth century. The costume suggests a date near the beginning of the century but it may be deliberately archaized. Although the heraldry shows no link with Huntly, the tradition that it was used for his funeral may be reliable.

The order of the procession is in some respects exceptional, which can perhaps be explained by the roll being used for assembling the procession before the arrival of the corpse (the place for which would be where the roll ends) and related paraphernalia. The roll contains 67 figures, three of whom are mounted; the brief inscriptions describing their functions are as follows:

1–18 'twenty four huodies or saulies tua & tua': a sheet containing six saulies (hired mourners) may be missing; they carry the arms of the defunct in buckram hatchments.

19–26 'the branshes of the defunk tua & tua': the arms of the eight great-grandparents (see nos. 53–60).

27–28 Inscription missing: two figures representing the Conductors of the Saulies who would ultimately lead the procession.

29–32 'four trumpeteirs twa in rank the ane tua to relive the uther tua'

33 '[the f]irst gentlman bearing the gunsion [gumphion] of taffita': the funeral gumphion was a flag showing the symbols of dissolution; 'gentlemen' are distinguished from others by wearing swords.

34 'The Pinsel in duil': a pinsel was a triangular flag containing the crest.

35 'the standerd in duil': a flag depicting the full achievement.

36 'his horsis [*sic*] in duil with his leder'

37 'the coat armes in cullors'

38 No inscription.

39 'the pinsel in cullors'

40 'Standerd in cullors'

41 'his horse and lakey in culors'

42 'The hed pece with his croun'

43 'his guantletes'

44 'his Arming sworde with his spurres'

45 'his corslet'

46 'The antique scheild with the hail arms theron'

47 'a rider in armes'

48–51 'the furst quarter of his armes; the second; the thurd; the fourt': these four flags are not found in other records of funeral processions.

52 'The horse of parliament trap with the fut mantle and his lakey'

53 'the first of his 8 branches the foir grand father [*sic*: this should be *grandsir*, a great-grandfather] & foir grand mother [*sic*] on the mothers side Square'

54 'the foir grandsire & foir grand dame on the fathers side pinsel'

55 '3 the grandsir and the grand[ame] on the mothers side'

56 '4 the grandsire & grandame on the fader side'

57 '5 the guidsir [grandfather] & ze guidame on the mothers side'

58 '6 the guidsir & guidame on the fathers side'

59 'the mother'

60 'the fathers armore': this is the correct position for these eight arms which have already appeared as nos. 19–26.

Details from 34

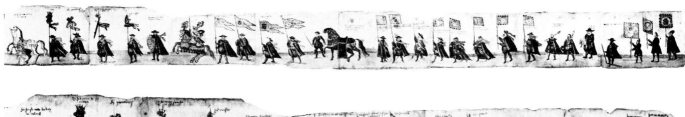

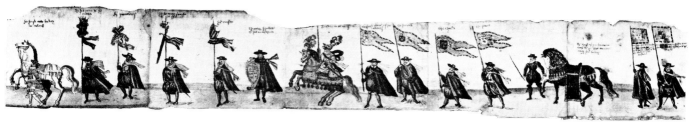

61–62 'Tua maisers in ane Rank': these figures would normally precede the 'Honours' which do not appear.

63 No inscription. This is assumed to be the herald presiding over the funeral, carrying the royal arms (deliberately wrongly shown) draped over his arm.

64 'Maister of cerimonies'

65 No inscription. This shows a full achievement normally carried behind the principal herald and before the defunct.

66 No inscription: a *Memento Mori*.

67 No inscription: a winged hour-glass and the words *Hora Fugit*.

The sociological significance of processions of this sort was great and they ought not to be seen as mere displays of pomp. They represent that moment in time when the continuity of the 'organized family' is assured by the ritual transfer of representation from the defunct to his successor. Because of this one finds the recurring contrast within the procession between the doleful and the colourful. The procession also represents the relationship between the inner family and the wider family of indeterminate relatives, vassals, and tenants, the *mansionata* or feudo-tribal *familia*. Ultimately, the procession is a ritual reunion of the organized family so that the group or community are made aware that, despite the dissolution of one part of that body, the community has not been diminished.

Records of this sort were common in the middle ages and many English examples survive. Apart from another version of this same roll no other Scottish examples of this period are known. Dating remains a problem. The handwriting and the manner of drawing, particularly in the faces, suggest a date later than the costume, perhaps as late as the 1620s or 1630s. The only clear link between a named painter and a work of this sort is in a description of the funeral of Margaret Ross, Lady Keir, at Holyrood in March 1633 (see William Fraser, *The Stirlings of Keir and their Family Papers*, 1858, pp. 51–3). This manuscript describes a procession similar in many ways (though much simpler) to the present roll, which, it states, was 'painted by James Workman without our directions'. This appears to mean that Workman prepared a marshalling roll like the present, though perhaps one that was more specific, and that he was able to do this without referring to the family. Workman is probably James Workman the elder who flourished from 1587 to 1633 and who became Marchmont Herald in 1597. He did armorial work at Edinburgh Castle while John Anderson was working there in 1617 (see also no. 35).

The Painted Ceiling of Rossend Castle

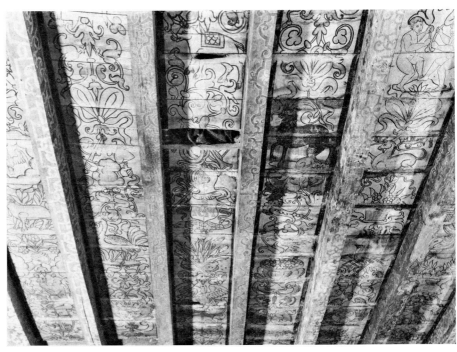

Detail of Sections C to H

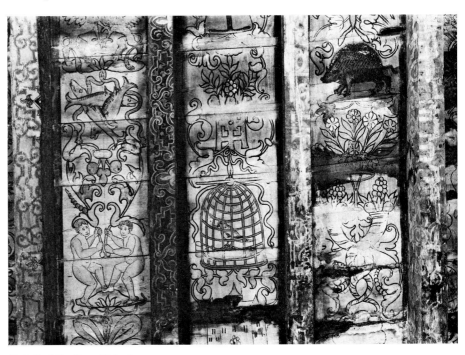

Detail of Sections G to I

35 A Painted Ceiling formerly in Rossend Castle, Burntisland, Fife

Tempera on 13 oak beams supporting boards divided into 12 sections; maximum dimensions of ceiling: 27 ft. 6 in. × 18 ft. 6 in. (8.382 m. × 5.639 m.): mounted 12 ft. 6 in. (3.810 m.) above floor level

Provenance: painted for Sir Robert Melville of Burntisland (see below); re-discovered *in situ* 1957: given by the Burntisland Burgh Council 1962.

Literature: M. R. Apted and W. Norman Robertson, 'Two Painted Ceilings from Rossend Castle, Burntisland, Fife', *Proceedings of the Society of Antiquaries of Scotland*, vol. civ, 1974, pp. 222–35.

Lent by the National Museum of Antiquities of Scotland

The ceiling has been removed from the hall or principal public room on the first floor of Rossend Castle in Burntisland. It was discovered by chance in 1957

behind a ceiling of much later date which had been attached to the underside of the beams.

Rossend Castle, which has been allowed to fall into dereliction, stands on a rocky platform of land overlooking the harbour of Burntisland. The original building, later extended, was a tower house, L-shaped in plan, the short leg of the L containing the stair which gave entrance to the hall at its north-west corner. A panel bears the date 1554 but the building may be earlier (see The Royal Commission on the Ancient Monuments of Scotland, *Fife, Kinross, and Clackmannan*, 1933, pp. 41–2). The ceiling, of the early seventeenth-century type, bears the initials SRM which almost certainly stand for Sir Robert Melville of Burntisland (d. 1635), who, with his father Sir Robert Melville, received a grant of the castle of Burntisland in 1588. The latter, however, resigned the lands in favour of his son during the same year. The younger Melville was knighted by 1594 and subsequently succeeded his father in December 1621 as Lord Melville of Monimail, a title created for the elder Melville in 1616. Terminal limits for the ceiling would thus seem to be *c.* 1594 and 1621. A date nearer the latter seems much more likely, and it is worth noting that Melville was instructed by the Scots Privy Council in early 1617 to prepare his home for the reception of the king (*The Register of the Privy Council of Scotland*, 1894, vol. xi, p. 87). There was much painterly activity in the royal residences during that year in connection with the king's visit and it may well be that Rossend was redecorated with this in mind.

The decoration consists of a multiplicity of emblems, purely decorative units such as birds, cornucopiae, or baskets of fruit, and continuous ribbons and arabesques tying the various parts together. It is impossible to discern any unifying philosophical thread in the emblems used and it is doubtful if one was intended. However, the meaning of each individual emblem was probably well enough known since they had had a wide currency in Europe since the fifteenth century, although the origins of many were medieval or classical. The moralizing emblem normally consisted of three parts, the motto, the visual symbol, and a text in verse or prose. Such engraved and printed material circulated widely, editions of the same book appearing in a number of cities at different times, often using the same blocks, and the emblem books became a common source of decorative imagery.

In the brief analysis of the ceiling which follows, reference is made to three such books which seem to relate directly or indirectly to a good deal of the imagery on the ceiling. These should be consulted for the fuller significance of the symbols used, while Apted and Robertson (cited above) provide a convenient summary. The three emblem books, two of

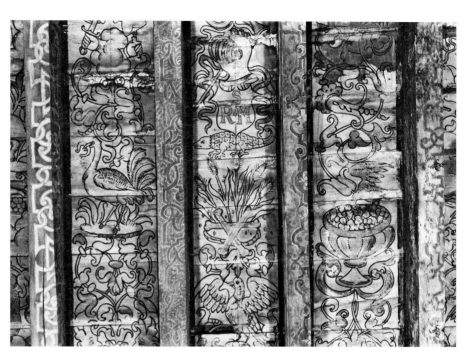

Detail of Sections D to F

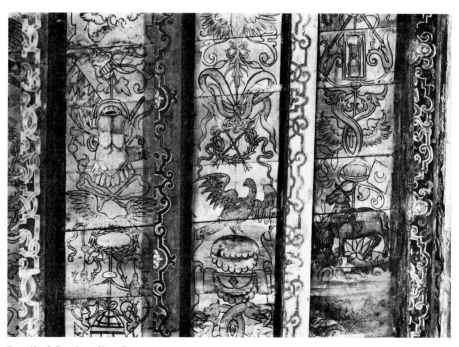

Detail of Sections J to L

which (Paradin and Whitney) are exhibited as nos. 36 and 37, are these:
(i) Claude Paradin, *Symbola Heroica*, Antwerp, 1583: first published at Lyons in 1557; London edition 1591 (this edition referred to by Apted and Robertson)
(ii) Geffrey Whitney, *A Choice of Emblemes, and other Devises*, Leiden, 1586
(iii) Gabrielle Rollenhagen, *Nucleus Emblematum Selectissimorum*, Cologne, 1611; also Arnhem, 1614.

Besides these three emblem books, some of the purely animal imagery appears to be derived, though indirectly, from Conrad Gesner's *Historiae Animalium*, two editions of which are exhibited (nos. 38 and 39) and to which reference is also made.

The ceiling is installed in the exhibition on the same alignment as it originally had in Rossend Castle. The north wall, blank at Rossend, has here had two windows inserted. Entry to the hall at Rossend was from the turret stair on the west wall

44

where it joined this north wall. To 'read' the ceiling, however, it is necessary to cross to the diagonally opposite (south-east) corner of the room and face west; then move rightwards, towards the north wall, until directly opposite the point of original entry.

The thirteen beams are decorated with five different strap-work patterns (a to e) arranged haphazardly, thus, reading south to north: 1(a); 2(b); 3(c); 4(d); 5(a); 6(b); 7(e); 8(c); 9(d); 10(a); 11(b, reversed); 12(e, reversed); 13(c, reversed).

The twelve sections of the actual ceiling, designated A to L (south to north) contain the following principal emblems or images (east to west):

A Arabesques
B Basket with fruit; covered cup (Paradin, p. 78); orb; three interlocked crescents, crowned (Paradin, p. 22: Rollenhagen, p. 99); animal, perhaps cat
C Angel; star encircled by snake, crowned (Paradin, p. 277: Rollenhagen, p. 62); lion with sword between its forefeet (Paradin, p. 88: Whitney, p. 116); bird ascending in cloud; ram; clasped hands holding posy; ape embracing young (Paradin, p. 235: Whitney, p. 188); bird with wings displayed
D Rabbit (Gesner, p. 394); beehive with poppies; knife and anvil (Paradin, p. 61); hands holding trowel and sword (Paradin, p. 122); ostrich

(Rollenhagen, p. 36); grotesque masks
E Musical instruments; musical instruments; rhinoceros (Gesner, p. 953); helmet and lance (Paradin, p. 68); shield with initials S R . M, for Sir Robert Melville; crocodile (Paradin, p. 71); grain sprouting from three interlaced bones (Paradin, p. 269: Whitney, p. 23); bird with wings displayed
F Dragon or salamander; basilisk; goat suckling wolfcub (Whitney, p. 49); raven drinking from cup filled with stones; bird with wings displayed, standing on rabbit
G Griffins combatant; three fish interlaced; Castor and Pollux; unicorn; basket with fruit; hand shaking snake into fire (Paradin, p. 199: Whitney, p. 166) winged helmet, serpents, and cornucopiae (Rollenhagen, p. 76)
H Dog; purse; basket with fruit; caged bird (Whitney, p. 101); castle; display of arms; blindfolded horse (Paradin, p. 150); hands clasping cornucopiae (Paradin, p. 298)
I Masks; bagpipes and crook (Paradin, p. 185); porcupine (Gesner, p. 632: Paradin, p. 27); crown with flowers; cornucopiae; bird shedding feathers before sun (Paradin, p. 183: Whitney, p. 177); thistles; stag's head
J Elephant and castle; ox skull; agricultural tools; goblet; mermen; display of arms; winged wreath; candle in lantern

K Birds on standard; upright fish; female statue; birds; sphinx (Paradin, p. 35); double-headed eagle transfixed by lance (Paradin, p. 184); wreath and crossed arrows; bird with wings spread; entwined dragons; camel and castle
L Turtle; torches and hour-glass; winged serpents; bonnet, crescent, and ox (Paradin, p. 297).

Two ceilings which offer parallels are those in Culross Palace and Nunraw in East Lothian. The former uses all three features of the emblem, picture, motto, and verse (drawn from Whitney) in a series of simulated framed paintings on a barrel-vaulted ceiling—stylistically not unlike the Dean panels (nos. 40–6); the ceiling at Nunraw contains many of the same elements, combined with a good deal of heraldry, and treated in a way very similar to Rossend.

There is no evidence as to the identity of the painter of the ceiling and this is presently the case with most of the decorative painting in Scotland. It is worth noting, however, that James Workman, who had worked at court prior to 1603, was a resident of Burntisland between the years 1604 and 1608 and probably for some time after the latter date (see M. R. Apted, 'Two Painted Ceilings from Mary Somerville's House, Burntisland', *P.S.A.S.*, vol. xci, 1960, p. 171).

Colour illustration

Related Books

HEROICA. 269
Spes altera vitæ.

Fru▪

36 *Symbola Heroica* by Claude Paradin
Antwerp, 1583

Lent by the National Library of Scotland

Many of the images on the Rossend ceiling derive from the emblems found in Paradin. One of these, the three interlocking crescents on section B, may have been included because it forms part of the Melville arms. Its moralizing aspect is as a symbol of constant change, with the motto, Donec totum impleat orbem— 'Till he replenish the whole world'. So, according to Paradin (in the English translation of 1591), the Church does not remain 'in one and the same state . . . whereby it cometh to pass that it is neuer free from vexation and trouble in this life'—an apt though presumably unintended prophecy (which the king, nevertheless, might have spotted at Rossend in 1617) of the ecclesiastical troubles of the next few decades.

The book is open at the emblem on page 269: Spes altera vitae—'Another hope of life'. The image is of grain sprouting from three interlaced bones, a symbol of the resurrection of the body which, like the grain, 'shall rise againe in glory in the last and general day of the resurrection of the flesh'. A quite close version of this emblem appears on section E of the ceiling.

37 *A Choice of Emblemes, and other Devises* **by Geffrey Whitney**
Leiden, 1586

Lent by the University of Glasgow

Several of the emblems on the Rossend ceiling relate to the illustrations in Whitney. The book is open at page 49, which shows a goat suckling a wolfcub— which will eventually seek to devour its benefactor. It is a symbol of ingratitude and a pointed warning to those 'Whoe in theire howse, doe foster up theire foes'. This emblem appears in section F of the ceiling.

38 *Historiae Animalium* **by Conrad Gesner**
Book I
Zurich, 1551

Lent by the National Library of Scotland

The emblem books must have drawn on works like Gesner's for much of their animal imagery. It is open at page 632 to show the porcupine, the root image for the porcupine on section I of the Rossend ceiling.

39 *Icones Animalium* **by Conrad Gesner**
An abridgement of Books I and II of *Historiae Animalium*
Zurich, 1560

Lent by the National Library of Scotland

Open at page 60 to show Gesner's rhinoceros which relates to the very primitive version on section E of the Rossend ceiling. Gesner's illustration was itself derived from Dürer's woodcut of 1515 (Bartsch, 136): this, based solely on descriptions and the sketches of others, introduced formations of scales and a horn on the back which do not actually occur on the animal. Such was the power of the image that it persisted even when the facts were fully known. The Rossend rhinoceros includes the scales and the extra horn, a provincial link in a long chain.

Seven Fragments from the Painted Ceiling of Dean House, Edinburgh

40 The Sacrifice of Isaac

Panel: $54\frac{1}{8} \times 51\frac{1}{8}$ (137.4×129.8)

Abraham is stopped by the angel as he prepares to sacrifice Isaac, who kneels before the altar. To the left of the hill are Abraham's two young men and his ass, while on the hill is the ram caught in a thicket which was offered up instead of Isaac.

41 King David Playing the Harp

Panel: $42\frac{1}{2} \times 41\frac{7}{8}$ (108×106.3)

David kneels with his harp before the book of Psalms in a curiously constructed room. The significance of the two figures with pikes is not clear.

42 Judith with the Head of Holofernes

Panel: $53\frac{1}{2} \times 44\frac{3}{8}$ (135.2×112.7)
Inscribed in top border: HOLOFERNES DECOLLATVS; and top left: BETHVLIA

Judith stands before the city of Bethulia, under siege by the Assyrians, with the besieging army lower left. On the right she slays the disarmed Holofernes in his tent.

43 St Luke

Panel: $41\frac{3}{4} \times 28\frac{1}{4}$ (106×71.8)
Inscribed at top: LVKE

The evangelist, author of the third gospel and Acts of the Apostles, writes watched by his traditional symbol, the ox. On the table beside him are palette and brushes, a reference to the tradition that he was a painter as well as a physician.

48

and the *Vision of Death* from the
Apocalypse: above these were depictions
of the four evangelists. (The second of
the principal compartments contained a
view of Edinburgh of the same type as
that in no. 46, in this case set on the
Lake of Galilee.) A fifth compartment
contained an elaborate *Allegory of the
Christian Life*. There were evidently
secular paintings as well, for a group of
musicians (then also in C. K. Sharpe's
possession) is compared with the 'larger,
but much ruder copy of the same design'
in Dean House. This has not survived.

The present series is in a style typical
of much of the surviving tempera
decoration of Scottish houses done in the
first three decades of the seventeenth
century. Given their general crudity and
lack of anything but the simplest
organization of parts, it is natural to see
them as being very secondary and not
involving much creative imagination, but
this may not be entirely true. A likely

source for much of the imagery would be
engraved material but this would not
supply colour, one of the stronger
features of this series. However, the
distinctive postures of, for instance,
Abraham and Isaac (no. 40) are certainly
more inventive than one would expect to
find the decorative painters producing,
and seem likely to have a sixteenth-
century source. Much of the architecture
is also derivative, Italianate buildings in
no. 40, and distinctively Flemish-looking
buildings in the *Sense of Taste* (no. 44)—
this latter painting also includes a curious
pergola. Sets of personifications of the
senses were also, of course, a very
common subject in sixteenth-century
northern art (see Agnes Czobor, 'The
Five Senses by the Antwerp Artist Jacob
de Backer', *Nederlands Kunsthistorisch
Jaarboek*, 1972, pp. 317–27). There is also
a very tenuous typological link between
the *St Luke* (no. 43), a rather massive
figure set in a rather cramped space, the

furnishings carefully depicted, and the set
of famous men painted by Justus of
Ghent about 1476 for the ducal palace of
Urbino.

Two other general sources may also
have provided imagery. From the
beginning of the seventeenth century
there are increasingly frequent references
to 'Arras hangings' in the inventories of
Scottish houses. Imported tapestry must
have been the most immediate part of the
decoration of many houses, especially on
the first or principal floor, and a ready
source of inspiration for the painter
working in the gallery on the top floor.
The formation of the trees in the *Sacrifice
of Isaac* (no. 40) suggest such an influ-
ence. The second likely source may have
been maiolica dishes, where the qualities
of the handling of colour and a certain
crudity are often rather similar. Personi-
fications of the senses with the same
attributes as shown here were common
on such dishes.

John Anderson

flourished 1601-1649

The only known works by John Anderson are the decorations of the small room in Edinburgh Castle in which James VI and I was born, which survives, and traces of painting at Huntly Castle.[1] Although it is not possible to exhibit work by Anderson, this note on his life is included because, firstly, he appears to have been the principal decorative painter of his day, and, secondly, because he was the master of the outstanding native Scottish painter of the seventeenth century, George Jamesone. Further, because he trained a painter of such relative sophistication, it is suggested in a number of places above that he himself may have produced portraits: if so, some of the unattributed Scottish painting of the period may be from his hand.

Anderson, son of the late Gilbert Anderson, became a burgess of Aberdeen on 6 October 1601.[2] On 8 May 1611 he was paid the quite large sum of £69 13s. 4d. by the treasurer of Edinburgh for painting and gilding the shutters of a clock at the Netherbow,[3] most of which (£66 13s. 4d.) on the same day he paid into the hands of the dean of guild for the privilege of being made burgess.[4] The following year, on 27 May, George Jamesone was entered his apprentice in Edinburgh for a period of eight years.[5]

During the early part of 1617 Anderson was working for the Marquess of Huntly at Strathbogie (Huntly Castle). On 25 March the Privy Council demanded that he be sent to Falkland Palace 'with his workeloomes' to carry out work for the king's approaching visit. Anderson had clearly been dilatory, for he was ordered to appear 'under the pane of rebellioun'. He was similarly ordered to appear at Edinburgh Castle on 3 June, having entered into an agreement with the master of works to begin the painting of some rooms on 30 May. He had not appeared because of 'ane idill and frivolous excuise'.[6] However, on 16 June, he was paid £100 for painting 'the rowme quhair [where] his Majestie wes borne'; he was also paid a smaller sum for marbling doors and chimneys in the new hall.[7]

There is a gap in the records of Anderson until 8 July 1633, when he reappears painting the council house at Holyrood.[8] In September 1634 he carried out work in St Nicholas, Aberdeen.[9]

A letter of 7 December 1634 from Sir John Grant of Freuchie to his mother mentions that Anderson has in his possession four of his portraits, which, a letter of three days later from Grant to Anderson himself makes clear, had been sent to Aberdeen to be framed. The second letter suggests a surprising intimacy between patron and painter: it further speaks of Grant's wish to have Anderson paint the ceiling of his gallery in Ballachastell, near Inverness, which employment he will give to no other man as long as Anderson is willing and able to do it.[10]

The last records of Anderson are his sale of properties in Aberdeen in 1647 and 1649.[11] His career appears to have been quite long: during it he had seen the art of easel-painting in Scotland transformed, largely through the efforts of his pupil Jamesone. His personal life has many gaps.[12] He had a son Adam[13] whose name often appears in the same context as Jamesone's and a daughter Euphemia married to an advocate, Alexander Davidson.[14] His wife, unnamed, was buried in St Nicholas on 20 December 1634.[15]

REFERENCES (1) See D. Thomson, *The Life and Art of George Jamesone*, 1974, pp. 51–2. (2) City of Aberdeen Records, Council Register, vol. 40, pp. 208, 799. (3) City of Edinburgh Records, Council Register, vol. 12, p. 125. (4) Ibid., Register of Burgesses, vol. 2, under date. (5) SRO, Burgh of Edinburgh Apprentice Register 1583–1647, under date. (6) *The Register of the Privy Council of Scotland*, vol. xi, 1894, pp. 75, 143. (7) SRO, Accounts of the Masters of Works, vol. xv, fo. 58. (8) Ibid., vol. xxv, fo. 45v. (9) AR, Kirk & Bridge Works Accounts 1571–1670, under date. (10) SRO, GD 248/46/2: Anderson corresponded with Grant's successor, Sir James, on 14 May 1638, over the last payments due for this work (ibid.). (11) SRO, Minute Book of the Burgh of Aberdeen Register of Sasines 1573–1694, under 2 June and 21 June respectively. (12) A difficulty here is the extremely common name: only references which also specify 'painter' have been admitted. (13) AR, Register of Sasines, vol. xxxix, fo. 179v. (14) *History of the Society of Advocates in Aberdeen*, edited J. A. Henderson, 1912, p. 144. (15) AR, Kirk & Bridge Works Accounts 1571–1670, under date.

Adam de Colone

flourished 1622-1628

Adam de Colone was almost certainly the son of the court-painter Adrian Vanson and his wife Susanna de Colone. The document which is most revealing about his life and career, a request for protection (or passport) issued by the Scots Privy Council on 3 February 1625, describes him as 'Adame de Coline sone to vmquhyle [the late] Adriane de Coline our paynter'.[1] The latter name does not appear in the Treasurer's Accounts nor in any other record of the Scottish court and seems certain to be an error for Adrian Vanson. Given the family's Netherlandish origins, it would not be unusual if Adam had assumed his mother's name after she had become a widow when he was still quite young. Adrian Vanson was certainly dead by 1610 but probably much nearer 1602. He had four children fairly evenly spaced between 1595 (the earliest surviving year in the Edinburgh parish baptismal registers) and 1601.[2] Adam must, therefore, have been born before 1595. From the events of his subsequent career 1593 would seem a reasonable guess, making him about nine or ten when his mother was widowed.

On approaching manhood de Colone went to the Low Countries 'for his better inhabling' in his father's craft. Several years were spent there before he returned to seek employment at the court in London. This was presumably in 1622, when he painted a copy of Gheeraerts's portrait of the 1st Earl of Dunfermline.[3] In July 1623 he was paid £60 at Whitehall for two portraits of the king,[4] presumably the full-lengths dated 1623 at Hatfield and Newbattle (see no. 47). According to his royal protection, de Colone had been in Scotland several months before seeking permission to travel to 'Flanders for some of his adois [business]'. One may doubt the seriousness of his stated intention to 'sattle [settle] his abroad in [the] said kingdome of Scotland' after his journey to the continent. He did not, in any case, depart immediately, for dated portraits appear down to the year 1628. These are generally of the more central figures among the Scottish nobility when compared with the patrons of his obvious rival during these years, George Jamesone: it remains unclear whether they were painted in Scotland or in London. The most significant of these patrons so far as establishing Adam de Colone's identity is concerned is George Seton, 3rd Earl of Winton, who between 10 February and 29 July 1628 recorded payments in his accounts to 'Adame the painter' for a number of portraits, including a sum of £40 for his own portrait (probably the one dated 1628 at Traquair).[5]

REFERENCES (1) *The Register of the Privy Council of Scotland*, vol. xiii, 1896, pp. 698-9. (2) See the biography of Adrian Vanson above. (3) Sold Christie's, 19 November 1965, lot 5. (4) *Acts of the Privy Council of England 1623-1625*, 1933, p. 50. (5) *Second Report of the Royal Commission on Historical Manuscripts*, 1871, p. 199.
See also: D. Thomson, *The Life and Art of George Jamesone*, 1974, pp. 55-9, 147-9.

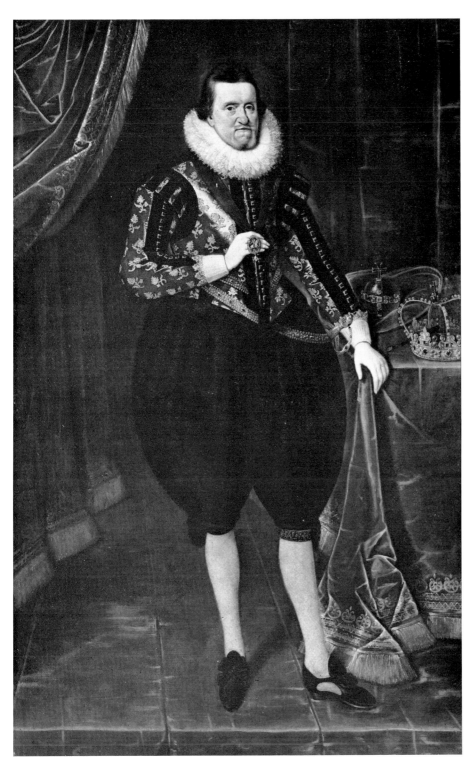

The equation of this portrait and the nearly-identical version at Hatfield with the Privy Council warrant of 4 July 1623 ordering Sir William Uvedale to pay 'Adam Colone' £60 for two pictures of the king seems unavoidable. Although a payment is recorded in the same year to a Richard Greenbury for a full-length of the king (*Acts of the Privy Council of England 1621–1623*, 1932, p. 398) it was on 30 January which was then still regarded as being in 1622. The king disliked sitting for his portrait, with the result that his later iconography is relatively easy to follow. From 1604 on there are the following basic patterns: the de Critz portrait (Scottish National Portrait Gallery; National Maritime Museum; and others), the Paul van Somer full-length of 1618 (Holyroodhouse), the full-length of *c.* 1620 (Windsor), the seated full-length by Mytens of 1621 (National Portrait Gallery, London), and the present portrait which seems to be derived from the van Somer portrait of 1618. (Auerbach tentatively attributes the Hatfield version to John de Critz, the elder, *after* van Somer.) In the present portrait the costume has been made more elaborate, van Somer's armour has been omitted, the tablecloth altered and a fringe added, similarly fringed curtains introduced in the background, and a series of sharp, rather flame-like highlights which are only hinted at in the van Somer lavishly deployed on the draperies. These latter features are characteristic of many of the portraits attributed to de Colone (see no. 49). Whether or not de Colone is guilty of plagiarism is not clear but the face is sufficiently different to suggest new sittings from the king: it lacks van Somer's sensitive freedom of handling and has the compact, circumscribed forms and rather aloof feeling which seem to be typical of de Colone. Nevertheless, their manners are quite close and there may have been some connection between them.

The pictures in the Privy Council warrant were painted for two Scots, the king's former tutor Sir Peter Young and Bernard Lindsay of Leith, a groom to the bedchamber, a fact which may hint at a reason why de Colone was given this employment—probably part of the employment at 'our royall court' referred to in the king's protection.

47 James VI of Scotland I of England (1566–1625)

Canvas: 83½ × 54½ (212 × 138.4)
Dated on right opposite left shoulder: 1623

Provenance: probably Sir Peter Young or Bernard Lindsay; with the Marquesses of Lothian at Newbattle Abbey since 1798 or earlier.

Literature: Oliver Millar, *The Tudor, Stuart and Early Georgian Pictures in the Collection of Her Majesty The Queen*, 1963, Text, p. 81; Roy Strong, *Tudor & Jacobean Portraits*, 1969, p. 179; Erna Auerbach, *Painting and Sculpture at Hatfield House*, 1971, p. 83; Thomson (cited above), pp. 56–7, 147.

Lent by the Marquess of Lothian

48 Ian, Patrick, and James Campbell of Ardkinglas

Canvas: 30 × 42 (76.2 × 106.7)
Inscribed by the subjects' heads, left to
right: ÆTATIS.SVÆ.9./1624;
ÆTATIS.SVÆ.10/1624; ÆTATIS SVÆ/4.
1624

Provenance: by descent to Janey Sevilla
Callendar, daughter of James Henry
Callendar of Craigforth and Ardkinglas,
and heiress of the Ardkinglas properties:
she married in 1869 Lord Archibald
Campbell, father of the 10th Duke of
Argyll; thence by descent.

Literature: Thomson (cited above),
p. 147.

Lent by the Duke of Argyll

The calligraphy of the inscriptions agrees
with that distinctive form found on most
of de Colone's works, including the
following five examples. The background
is atypical in its inclusion of a quite
highly wrought pillar on the extreme
right. An interest in the minutiae of
costume and the texture of materials is,
however, typical (cf. no. 51). A quality of
charm pervades the picture, rather over-
laying the usual austerity of de Colone's
images. This sensitivity to the expression
of childhood is as marked as in no. 49,
but it is conveyed here by a handling of
paint which is more polished, rather more
old fashioned, than the fluid and sug-
gestive use of paint in the head of the
older child in the later picture.

49 George Seton, 3rd Earl of Winton (1584–1650) with his sons George and Alexander

Canvas: 44½ × 33 (113 × 83.8)
Inscribed by the subjects' heads: ÆTATIS
40/1625; ÆTATIS. 5; ÆTATIS. 12

Provenance: probably at Keith Hall from
the second half of the eighteenth century,
when the estates came into the possession
of the 10th Earl Marischal whose great-
uncle the 7th Earl Marischal had married
a daughter of the 3rd Earl of Winton: the
10th Earl Marischal's heir became 5th
Earl of Kintore.

Literature: Thomson (cited above),
pp. 56, 58–9, 147–8.

Lent by the Kintore Trustees

Along with the three-quarter length of
the same sitter (dated 1628) at Traquair,
the present picture is a vital key to un-
locking the artistic personality of Adam
de Colone. Winton's account book (cited
above) records two payments to 'Adame
the painter': the first, of £86 13s. 4d., for
portraits of Lord Erroll, Lady Hay, and
James Maxwell, which remain un-
identified, the second (in 1628) of £40 for
Winton's own portrait given to his sister
(this latter payment is between one for
plaster ceilings at Winton Castle and one
made to the keeper of the monuments at
Westminster Abbey and so does not
establish if the painting was done in
London or Scotland). There appear to be
three surviving portraits of Winton, the
present, the one at Traquair, and a head
and shoulders at Duns Castle, which is
probably by the same hand as the first
two. Because of the date, and a family
link between Winton and the earls of
Traquair, it is tempting to equate the
portrait at Traquair with the one in the
accounts, equating in turn 'Adame' with
Adam de Colone.

The present portrait is thus assumed to
show Winton patronizing de Colone at a
slightly earlier date. Apart from stylistic
criteria, the distinctive inscriptions agree:
it is also worth noting that both pictures
are basically small half-length canvases, a
size common among painters of Nether-
landish origin.

In painting the present picture de
Colone produced what is his most
beautiful surviving work. It is imbued
with a feeling of profound tenderness,
despite a certain immobility in the forms.
The figures, which are set in a very
shallow space with the typical fringed
curtains in the upper corners, have varia-
tions in their treatment which suggest the
different sources of de Colone's style.
Winton, rather hieratic in feeling, is
basically Jacobean-Netherlandish in con-
ception, while the younger child is dis-
tinctly provincial: on the other hand, the
elder son has a fluidity of treatment which
is more modern and more positively

Detail from 49

50 John Erskine, 2nd Earl of Mar (1562–1634)

Canvas: $24\frac{1}{2} \times 20\frac{7}{8}$ (62.3 × 53)
Inscribed top left: ÆTATIS.SVÆ.64../
1626

Provenance: probably by descent through the sitter's son Sir Charles Erskine of Alva and Cambuskenneth to the latter's grandson James Erskine, Lord Alva; thereafter by descent and bequeathed by A. Erskine-Murray, 13th Baron Elibank 1973.

Literature: Thomson (cited above), p. 148.

Scottish Portrait National Gallery

Recent restoration has revealed the vigour and freshness of the handling of face and collar. De Colone's use of pigment, which is probably seen at its best in this painting, where it is especially sensitive to the nuances of the flesh, tends to consist of series of quite small brush-strokes tightly knit into one another—for example, on the sitter's right cheek and the line of his jaw. This method is not far removed from that of Mytens in his more intimate portraits (e.g. his *Self-portrait* at Hampton Court).

Mar was for long a friend of the king, following him to England in 1603. He was installed a knight of the garter in July of that year and it is this order which he wears in the portrait. The ribbon, which should be blue, has probably been painted with azurite which stains with oil: this would produce the now irreversible green (there are, in fact, traces of unaltered blue at its edges). Mar became Treasurer of Scotland in 1616, a position which he held until 1630, though it was much reduced in significance on

Dutch, suggesting Miereveld or Paulus Moreelse. It is, in fact, interesting to note that a painting of a young boy, clearly by de Colone, has been quite convincingly included in Moreelse's *œuvre* (see C. H. de Jonge, *Paulus Moreelse*, 1938, p. 110, no. 207). The style is, in fact, one quite widely disseminated in the areas peripheral to the Low Countries, especially in Germany, Denmark, and Sweden: a portrait of Friedrick Casimir of Julich by an unknown artist (dated 1624) at

Gripsholm (no. 1090) is treated in a way very similar to the figure of Winton, while a portrait of a boy in Cologne (Wallraf-Richartz-Museum, no. 2175, dated 1620) described, interestingly, as by an artist of the Cologne School, is extraordinarily close in feeling and treatment to the elder son in the present portrait.

There is a companion portrait by the same hand at Traquair of Winton's wife Anne Hay with two of their daughters (also dated 1625).

Colour illustration

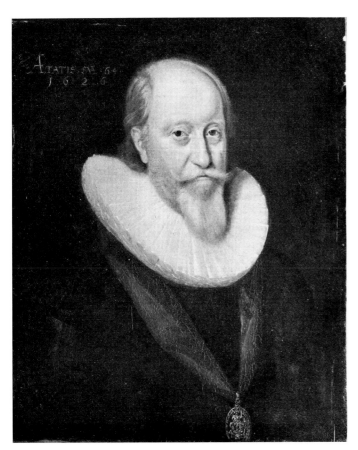

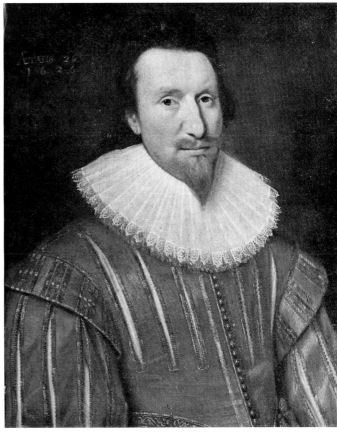

the king's death in 1625. He was in London in January 1626 to discuss the limitation of his powers with Charles I and it is not inconceivable that the portrait was painted at this time.

One surprising fact which has been revealed by removal of an old relining canvas during restoration is that the portrait is not painted on conventional canvas but on a piece of diaper weave damask of fine linen. Apart from some regular, horizontal marks visible on the beard and collar, there is no suggestion on the surface of the picture of the intricate pattern of this material. Further, the material, before use as a painting surface, has been in places meticulously darned, suggesting that it is, in fact, a piece of cast-off domestic furnishing. In view of the eminence of the subject this is perhaps doubly surprising, and it casts a new and interesting light on the practical aspects of seventeenth-century painting.

51 James Erskine, 6th Earl of Buchan (c. 1600–1640)

Canvas: $24\frac{7}{16} \times 19\frac{1}{2}$ (62 × 49.5)
Inscribed top left: ÆTATIS . 26 / 1626

Provenance: probably by descent through the sitter's father and subsequent Earls of Mar and Earls of Mar and Kellie.

Literature: John Bulloch, *George Jamesone*, 1885, pp. 156–7; Thomson (cited above), p. 149.

Lent by the Earl of Mar and Kellie

Formerly attributed to Jamesone. Recent restoration has revealed the long-obliterated inscription, the forms of which support the new attribution. Stylistic features which are seen to be characteristic of portraits attributed to de Colone are the diagonal bias of the head (cf. Winton in no. 49 above), knitting of brush-strokes into a tight pattern, especially on the line of the jaw (cf. no. 50 above), the hooding of the eye-ball by a rather tautly curved upper eyelid, and the use of a lean, pale pigment, dragged across a darker base to produce the highlights in the hair (cf. no. 53 below).

The subject was the eldest son of Treasurer Mar (no. 50) by his second wife Marie Stewart. He married Mary Douglas, Countess of Buchan and became Earl of Buchan in her right. He was a groom of the bedchamber to Charles I and spent much of his life in England.

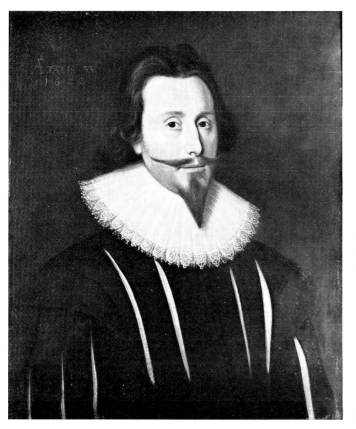

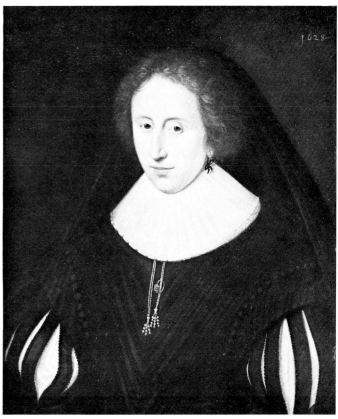

52 John Hay, 1st Earl of Tweeddale (1595–1654)

Canvas: 25⅞ × 21 (65.7 × 53.3)
Inscribed top left: ÆTATIS . 33 / 1628

Provenance: family ownership until sold at Christie's, 1 May 1970, lot 45: bought by the grandson of the 11th Marquess of Tweeddale.

Literature: Bulloch (cited above), p. 182; Thomson (cited above), p. 149.

Lent by Hugo Morley-Fletcher, Esq.

Companion to no. 53 below. Attributed to Jamesone by Bulloch. Like its companion, it has more recently borne an attribution to Gilbert Jackson. It has, however, none of that painter's characteristic *naïveté*: it does have many of those features which have been noted as characteristic of de Colone and is certainly by the same hand as no. 51 above.

Lord Hay of Yester, though a signatory to the Solemn League and Covenant, remained acceptable to Charles I and was created Earl of Tweeddale in 1646.

53 Margaret Hay, Countess of Dunfermline (c. 1592–1659)

Canvas: 26½ × 21 (67.3 × 53.3)
Dated top right: 1628...

Provenance: family ownership until sold at Christie's, 1 May 1970, lot 46: bought by the grandson of the 11th Marquess of Tweeddale.

Literature: Bulloch (cited above), p. 182; Thomson (cited above), pp. 148–9.

Lent by Hugo Morley-Fletcher, Esq.

Companion to no. 52 above. Formerly attributed to both Jamesone and Gilbert Jackson, it has, in fact, many of those Netherlandish features typical of de Colone. Though the inscribed date is abbreviated, it is clearly of the same type as that on the other pictures exhibited. Despite a certain smoothness (the handling of paint is much more 'finished' than in the portrait of Mar, no. 50), the face has a degree of particularity which makes it one of de Colone's most satisfying portraits.

The subject, clearly a widow as both her dress and the ring tied to the bandstring show, has long been traditionally identified as Margaret Kerr, Lady Hay of Yester (1570–1645), an identification which can be disposed of purely on the evidence of the date on the painting and the age of the sitter. It is so obviously pendant from no. 52 above that an identity must be sought in that context.

Lord Hay's first wife Jean Seton, daughter of the 1st Earl of Dunfermline, died before 19 January 1627 and is, therefore, discounted. His sister Margaret Hay, however, married this same Earl of Dunfermline (as his third wife) in 1607 and was widowed in 1622: she did not remarry until 1633. That the sitter is indeed Margaret Hay is virtually confirmed by comparison with an earlier portrait by Gheeraerts (formerly at Yester)—a conclusion supported by a comparison with the Van Dyck portrait of her eldest son, the 2nd Earl of Dunfermline, which shows a face extraordinarily similar in appearance.

Unidentified Painter

flourished 1633-1637

There are no clues as to the identity of this painter. The following four portraits form a distinct stylistic group and bear inscriptions with identical forms. One or two other portraits of the period seem related stylistically but do not have the confirmatory evidence of the inscriptions. These inscriptions are a curious amalgam of the forms used by Jamesone and Adam de Colone: the first line giving the date being rather like the former's italic inscription, the second line quoting the subject's age close to de Colone's capitals with sharp serifs. The figure posited is, in fact, someone not unlike Jamesone in many respects but with certain features that distinguish de Colone as, for example, the fringed curtains in no. 56.

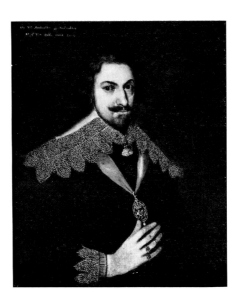

54 Sir William Anstruther (c. 1576–1649)

Canvas: 30 × 25 (76.2 × 63.5)
Inscribed top left: *Anno. 1633.*/ ÆTATIS SVÆ 57

Provenance: family ownership since painted.

Lent by Sir Ralph Anstruther

This is the earliest known work by the painter who is only identifiable by the dates between which he flourished, 1633-1637. The sitter was a groom of the bed-chamber to James VI and I. He was made a knight of the Bath in 1603, which order he wears. He was also in favour with Charles I and the portrait may be connected with the king's visit to Edinburgh in 1633.

One distinctive stylistic feature of this painter's work is the extreme degree of detail in the collar. A related painting is at Carmichael House.

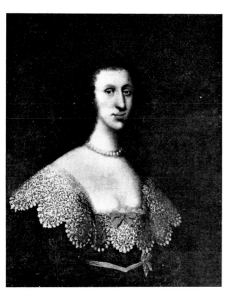

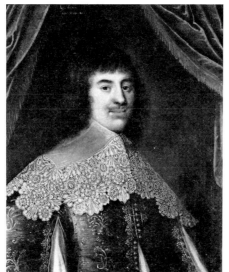

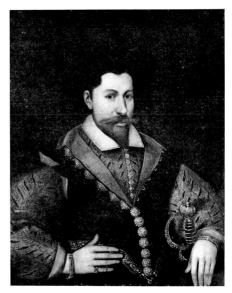

55 Margaret Stewart, Countess of Queensberry (c. 1622–1673)

Canvas: 30 × 25 (76.2 × 63.5)
Inscribed top left: *Anno 1637* / ÆTATIS 15

Provenance: early history untraced; in the Charles Kirkpatrick Sharpe sale of January 1852 (said to have been 'from a house near Traquair').

Lent by the Duke of Buccleuch and Queensberry

Quite reminiscent of Jamesone, even showing some of his characteristic damage; formally rather soft and shapeless, the lace rather overpowering the design.

The sitter was the eldest daughter of John Stewart, 1st Earl of Traquair and Catherine, daughter of the 1st Earl of Southesk (no. 70). She married James, 2nd Earl of Queensberry after a contract of 26 March 1635; her eldest son William was born in 1637. Given the picture's early history, there is perhaps some reason to doubt the traditional identification: the inscription, it should be noted, gives a date of birth in the same year as her elder brother John, 2nd Earl of Traquair. If the Traquair part of the tradition is correct, then some consideration might be given to identifying the subject as Elizabeth, Margaret's younger sister, who married Patrick, Lord Elibank in 1643 (see no. 56 below).

56 Patrick Murray, 2nd Earl Elibank (c. 1617–1661)

Canvas: 30 × 25 (76.2 × 63.5)
Inscribed top left: *Anno 1637* / ÆTATIS SVÆ. 20.

Provenance: family ownership since painted.

Lent by A. Erskine-Murray, Esq.

Has been attributed to Gilbert Jackson. In drawing it is quite close to Jamesone, especially the tendency to distort the rear of the head by pulling it out towards the picture plane. The curtains, however, are close to de Colone, though rather more slapdash in treatment (cf. nos. 47 and 49). Stylistically, the most striking and individual feature of the painting is the almost nightmarish quality of detail shown in the lace of the collar.

The subject, while master of Elibank, was an adherent of Montrose; he married in 1643 Elizabeth Stewart, daughter of the 1st Earl of Traquair.

57 Sir James Anstruther (c. 1555–1606)

Canvas: 30 × 25 (76.2 × 63.5)
Inscribed top left: *Anno. 1591* / ÆTATIS SVÆ. 36.

Provenance: perhaps family ownership since painted.

Exhibition: this, or a similar portrait, was exhibited in Edinburgh, *Antiquities, Works of Art and Historical Scottish Relics*, 1856 (lent by James Gibson Craig).

Literature: catalogue of above exhibition, 1859, p. 143.

Lent by Sir Windham Carmichael-Anstruther

Clearly a seventeenth-century painting and not of the date inscribed on the canvas. The form of the inscription particularly and the rather limp manner relate it to the three other pictures in this group. It is a copy of a picture of the sort that has been ascribed to Adrian Vanson—the pattern is seen to be very close to the portrait of Sir Thomas Kennedy of Culzean (no. 13). The present portrait may, therefore, be regarded as a fairly accurate record of an original painting by Vanson, which may have been a full-length.

The Black Book of Taymouth

58 Sir Colin Campbell of Glenorchy (1577–1640) from the Black Book of Taymouth

Water-colour: $7 \times 4\frac{3}{4}$ (17.8×12.1)
Inscribed in cartouche at top: DOMINVS COLINVS CA / MPBELL DE GLENVRQVHAY; inscribed on left: *Ætatis Suæ, / 56, / Anno Domini / 1633.*

Literature: *The Black Book of Taymouth with other papers from the Breadalbane Charter Room*, edited Cosmo Innes, 1855, pp. i–viii, 1–106; D. Thomson, *The Life and Art of George Jamesone*, 1974, pp. 28–9, 105, 107, 108.

Lent by Armorer, Countess of Breadalbane

The Black Book of Taymouth was undertaken in June 1598 on behalf of Sir Duncan Campbell, 7th laird of Glenorchy, by a William Bowie who was later tutor to his grandsons. It is basically a genealogy of the Campbells of Glenorchy from the beginning of the fifteenth century, in the person of Duncan Campbell of Lochow whose son Colin was the 1st laird, to 1648 during the lifetime of Sir Robert Campbell, the 9th laird (and 3rd baronet). The later pages are by a different author. Besides tracing the descent of the family and its links with other families, much emphasis is placed on the acquisition of property which is recorded in detail. Most space is given to the life of Sir Duncan and a good deal of this to his part in the suppression of the MacGregors. Details of foreign travel, costs of building operations, and improvements on the estates are also included. The record becomes rapidly less impressive in Sir Robert's time and dries up with a laconic list of debts, clearly connected with the growing unrest of the time.

The records of the 8th laird, Sir Colin Campbell, refer to his patronage of a 'German' painter in 1633 and George Jamesone in 1635 (see nos. 65 and 66). From what is known of Glenorchy's obsession with his genealogy it appears likely that the illustrations in the Black Book were added by him. There are nine of them and they are grouped together at the back and upside-down in relation to the text. Each is a full-length depiction of a laird suitably armoured, with the exception of the first which shows the founder of the family, Duncan Campbell of Lochow, and his two sons, Archibald, who was *father* of the 1st Earl of Argyll (both here and on the *Genealogy* (no. 66) he is called Earl of Argyll), and Colin, the 1st laird.

They are bold and decorative, but quite unsubtle images, with the exception of that of Sir Colin, which is exhibited. They have a kind of accomplished primitivism which is very like the work of the German painter who provided the full-size portraits of the lairds for Balloch, and they are probably by him. However, that of Sir Duncan, 7th laird, is related to the 1619 portrait (no. 32) and it bears that date as well as the date of death which is the only date on the others. It is just possible, therefore, that they are by the same hand and that they do not date from Sir Colin's time.

The portrait of Sir Colin has an individuality the others totally lack and is clearly from life. For this reason it is just possible that it is by the same hand as the others, the confrontation with an actual sitter altering the painter's manner to an unrecognizable degree. It may, however, be the work of Jamesone, though it is dated two years earlier than his first known work for Glenorchy. It is related to the portrait in the *Genealogy* and has a finely graded feeling for tone quite absent from the other illustrations—the face is crisply painted in series of carefully related small brush strokes. Also included are subtly shaded cast shadows giving some sense of surrounding atmosphere, a quality totally lacking in the rest.

George Jamesone
1589/90-1644

George Jamesone[1] was born in Aberdeen at some time between mid-1589 and mid-1590, the third son and fourth child of a master-mason, Andrew Jamesone, and his wife Marjory Anderson. Both of these families were prominent and well established in Aberdeen. The future painter's elder brothers, Andrew and David, died quite young, David before 1607, Andrew, the eldest, in 1613, the year after George had been apprenticed as a painter in Edinburgh to John Anderson (see page 49). A younger brother, William, later practised as a writer in Edinburgh and survived until 1632.

Jamesone's apprenticeship was for eight years but Anderson's activities towards the end of the decade suggest that the apprenticeship must have meant very little by the time it was completed. It remains something of a mystery exactly what Jamesone learned from Anderson, and it is not inconceivable, though there is no proof for it, that he went abroad prior to 1620 when his first known portrait (Sir Paul Menzies) was painted. Nevertheless, despite the relative sophistication of his manner, Jamesone seems to have been a product of the decorative painters and he retained contacts with them throughout his life.

His earliest patrons were from the burgess and academic circles of Aberdeen but within two or three years he was painting the leading nobility of the north-east and soon of the entire country. Until 1628 he must have had competition from Adam de Colone, a Scot but Netherlandish by training and background, who attracted the more central of the nobility, probably by his relatively more international manner. This competition, however, came to an end in that year with de Colone's disappearance from the scene and Jamesone held a virtual monopoly for the rest of his life, a situation which led to overproduction and dramatic variations in quality. Late in 1629 he painted what is probably his finest surviving portrait, that of the young Earl of Montrose (no. 62), whom he was to paint once more in 1640 in vastly changed social conditions.

About 1625 Jamesone married Isobel Tosche by whom he had at least nine children, five sons and four daughters. The first-born was Marjory who ultimately married an advocate John Alexander; of the three other daughters, Elizabeth, Isobel, and Mary, only the latter reached adulthood. None of the sons lived beyond childhood. Among the godfathers to Jamesone's children there was a wide social range: Paul Menzies, provost of Aberdeen, George Keith, younger son of the Earl Marischal (whose mother, Lady Mary Erskine, Jamesone had painted in 1626 (no. 60)), George Morison, a bailie and close associate of Jamesone during the troubles, Robert Skene, a painter and glasswright, Andrew Strachan, also a painter, and Patrick Jack, a dyer.

By 1630 Jamesone and his wife had rights in five dwelling-houses in Aberdeen, though they presumably continued to live in the house on the north side of the Schoolhill in Aberdeen which his father had conveyed to Jamesone in 1607. He was clearly highly successful and from 1633 he became active from Edinburgh, though he did not settle there. By May 1635 he had become tenant of a lodging on the north side of the High Street near the Netherbow Gate. It is not unlikely that Jamesone was actually invited to Edinburgh by the Council in 1633 to help them prepare for the triumphal entry of Charles I, for reference is made in the Council Register to his 'extraordiner paynes'. These pains included painting a series of Scottish monarchs, of which twenty-six survived until recent years (see nos. 63-4). Later in the same year he paid a short visit to London, his only recorded journey outside Scotland.

Towards the end of 1634, if not earlier, he began to be patronized by Sir Colin Campbell of Glenorchy, at first in the provision of 'fancy' portraits of his female ancestors (see no. 65) and portraits of Scottish kings and queens. These were followed by the *Glenorchy Family-tree* in 1635 (no. 66) and a series of portraits of contemporaries with whom Campbell had family ties in 1636-7. These included the young covenanter, the Earl Marischal (see nos. 67-9). During this period, on 6 April 1636, Jamesone took his only known apprentice, Michael Wright, son of a James Wright, tailor and citizen of

London. It remains unclear why Wright should have come north to learn the art of painting.

Three of Jamesone's best portraits date from 1637, David, 1st Earl of Southesk (no. 70), his brother, Sir Alexander Carnegie, and Sir William Nisbet of Dean (also a patron of the decorative painters: see the notes to nos. 40–6). Rather later are a series of self-portraits (see no. 72) which suggest some of Jamesone's social pretensions and where he may see himself as a kind of Rubens. One of these (now at Fyvie) is, in fact, dominated by the figure of his young wife whom he presents with pride, a rather Rubensian touch. In 1635 he had created an ornamental garden beside the Denn Burn in Aberdeen, which the poet Arthur Johnston was to single out as one of the notable features of Aberdeen. In 1633 and 1643 he acquired rights in two estates outside Aberdeen, the first at Fechil near Ellon, the second at Esslemont in the same area, a transaction which was in effect a loan of 16,000 merks (about £11,000 Scots) to the Earl of Erroll, Lord High Constable of Scotland. He also took part on Aberdeen's behalf in a mission to the forces of the covenant in March 1639, perhaps because of his degree of familiarity with the Earl Marischal's family. This incident led to Jamesone's confinement in Edinburgh in the latter half of the year and his appearance in a Privy Council roll of 'delinquents'.

In this period of social upheaval Jamesone's work deteriorated to a considerable degree. Demand probably also dwindled and, in any case, Jamesone was now relatively rich. His daughter Mary was born in July 1644 in the midst of a fresh wave of unrest and on 13 September the forces of Montrose (now a supporter of the king) sacked Aberdeen. It is not certain if Jamesone was still alive by this date but he was certainly dead by 11 December, when his daughters were served as his heirs. His elegy by David Wedderburn links his name with Buchanan and is also evidence that Jamesone had acquired a near legendary status during his own lifetime. It further states, with a degree of truth, that no hand had been found to which he could pass on his torch. His widow remarried in 1649 and survived until 1680.

REFERENCES (1) This account is drawn from the writer's, *The Life and Art of George Jamesone*, 1974: this includes a chronological calendar of all the known documents referring to Jamesone (pp. 129–45) where full references can be found.

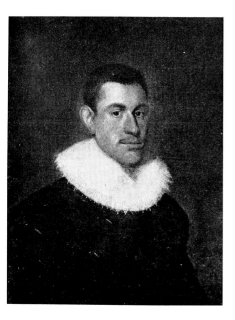

59 Unidentified Man

Canvas: 27 × 21½ (68.6 × 54.6)
Inscribed top left: *Anno* [remainder indecipherable]

Provenance: untraced.

Literature: John Bulloch, *George Jamesone*, 1885, no. 170; Thomson (cited above), p. 55 and no. 3.

Lent by John Forbes-Sempill, Esq., and the National Trust for Scotland, Craigievar Castle

This is one of the earliest existing portraits by Jamesone, probably about 1624, when his subjects were still mainly drawn from the burgesses and scholars of the north-east. It lacks the authority and roots of de Colone's style but, perhaps because of this relative freedom from a rigid tradition, it has a freshness and forthrightness of a quite distinct kind—an immediately compelling image of a type Jamesone was rarely to equal. Though in many ways provincial it has a rich, even casual control of light and shade, and a consequent sense of atmosphere, which seem to hint at an awareness of Italian models.

Traditionally identified as William Forbes (d. 1627), father of the 1st baronet of Craigievar, this is clearly impossible as he was already a man of considerable substance as early as 1610, when he undertook the ultimate building phase of Craigievar. It may, therefore, represent his son William who succeeded in December 1627 and was created a baronet of Nova Scotia in April 1630.

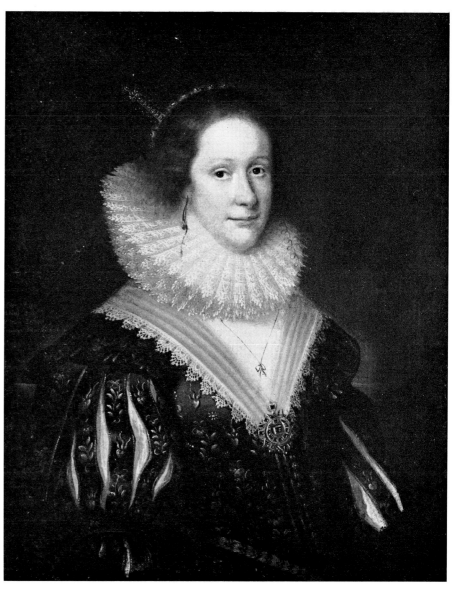

60 Mary Erskine, Countess Marischal (b. c. 1597)

Canvas: 26½ × 21½ (67.3 × 54.6)
Inscribed on left above shoulder: *Anno 1626./Ætatis 29./Maria Ersken/ Countess Marschaill*

Provenance: probably by descent through the sitter's brother Sir Charles Erskine of Alva and Cambuskenneth to the latter's grandson James Erskine, Lord Alva; thereafter by descent to Alexander Erskine-Murray, from whom purchased 1908.

Exhibition: Royal Academy, *Scottish Art*, 1939, no. 13.

Literature: Bulloch (cited above), no. 143; catalogues of the National Gallery of Scotland, 1957 edition, p. 135, and 1970 edition, p. 47; Thomson (cited above), pp. 60, 61, and no. 9.

Lent by the National Gallery of Scotland

By 1625, in which year he painted a full-length of the Earl of Rothes, Jamesone appears to have established a reputation with the north-eastern nobility. This portrait belongs to a group of five surviving (probably originally seven) portraits of sons and daughters of the 2nd Earl of Mar (Treasurer Mar) and his second wife Marie Stewart which Jamesone painted in the mid-20s. It is interesting to note that Mar himself and his eldest son James were painted in 1626 by Adam de Colone (see nos. 50 and 51).

This is one of the most beautiful and most satisfying of Jamesone's paintings, perhaps surpassed only by the portrait of the young Montrose (no. 62). Certain features may derive from the influence of de Colone, the diagonal bias, the wealth of detail in the jewellery, and the embroidery of the dress, while others may indicate some knowledge of the work of

Cornelius Johnson, but it has a human immediacy, a sensuous feel for light and colour, and an ability to suggest an enveloping atmosphere which are quite personal. While Jamesone's portrait lacks the technical virtuosity of de Colone's *Countess of Dunfermline* (no. 53), it has a sense of sympathy for the human personality which is in contrast to the latter's rather more inaccessible view of character.

Mary Erskine married the 6th Earl Marischal after a contract of 1607 at what must have been, even for that time, a remarkably early age. Jamesone, who was to paint her son William, the 7th Earl, in 1636 (no. 67) seems to have been on familiar terms with the family: George, her second son, was godfather to the painter's son George in 1633.

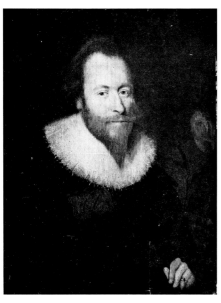

61 Arthur Johnston (c. 1577–1641)

Panel: $25\frac{3}{4} \times 22\frac{3}{4}$ (65.4 × 57.8)
Illegible inscription top left

Provenance: almost certainly in Marischal College since the seventeenth century: according to the Earl of Buchan it was given to the College by Jamesone in 1637 (Society of Antiquaries of Scotland, MS. 597, p. 7).

Literature: John Davidson, *Inverurie and the Earldom of Garioch*, 1878, p. 168; Bulloch (cited above), no. 21; *Musa Latina Aberdonensis*, vol. ii, edited by Sir William Geddes, 1895, p. xiii; James L. Caw, *Scottish Painting, Past and Present*, 1908, p. 10; Thomson (cited above), no. 27.

Exhibitions: Aberdeen, *Archaeological Exhibition*, 1859, no. 135; Edinburgh, *Scottish National Portraits Loan Exhibition*, 1884, no. 58; perhaps Glasgow, *Scottish Exhibition*, 1911, no. 44; perhaps London, Whitechapel Art Gallery, *Scottish Art and History*, 1912, no. 95

(these last two may have been the King's College portrait of 1629).

Lent by the University of Aberdeen (Marischal College)

This portrait has often been confused with another of the same subject by Jamesone of 1629 in King's College. Geddes read the date as 1621 and the sitter's age as 42 (which conflicts with his own convincing argument that the sitter was born in 1577); Caw also gives this date. Davidson states that it is dated 1623 and a copy at Caskieben bears this date. The engraving in the Middelburg edition of Johnston's poems of 1642 is lettered '1639. Ætat. 52', which has given the traditional date of his birth. However, the 1739 edition of his *Psalmarum Davidis Paraphrasis* carries a portrait (different in many respects from the present but with the left hand clutching some kind of branch which suggests an iconographical link) which is lettered 'Ætat. 52. 1629'. This gives a date of birth which agrees with Geddes's arguments on this point. This date also agrees with the costume and the general accomplishment of the portrait, which is much closer to the *Montrose* (1629) than the more archaic portraits of the early 1620s (for example, the *Robert Gordon of Straloch* of about 1625—Thomson, no. 4). The problem, however, cannot be decided with certainty until the picture is cleaned.

Johnston was professor of philosophy at Heidelberg by 1601 (another reason to accept the earlier date of birth); he was later at the university of Sedan, where he became professor of physic in 1610. He had returned to Aberdeen by 1622 when he became a burgess and most of his Latin verse was produced after that date. He referred to Jamesone twice in his poetry; he also baptized his son Alexander in 1636.

62 James Graham, 1st Marquess of Montrose (1612–1650)

Panel: 26 × 22 (66.1 × 55.9)
Signed lower right: *Jamesone Fec.*; inscribed top left: *Anno 1629 / Ætatis 17*

Provenance: family ownership since painted.

Exhibitions: Aberdeen, *Archaeological Exhibition*, 1859, no. 153; Royal Academy, *Scottish Art*, 1939, no. 10; Royal Academy, *British Portraits*, 1956–7, no. 67; Glasgow, *Scottish Painting*, 1961, no. 5.

Literature: Mark Napier, *Memoirs of the Marquis of Montrose*, 1856, vol. i, pp. ii–v; Bulloch (cited above), no. 179; James L. Caw, *Scottish Portraits*, 1903, vol. i, p. 78; Ellis Waterhouse, *Painting in Britain 1530 to 1790*, 1962, p. 4; Thomson (cited above), pp. 61–3, and no. 25.

Lent by the Earl of Southesk

Painted, or at least started, between 3 and 5 November 1629, when the young Earl of Montrose was made an honorary burgess of Aberdeen. The price of £26 13s. 4d. was paid by Montrose's kinsman, Sir Robert Graham of Morphie, and the portrait was probably a wedding present. Montrose married Magdalen Carnegie, daughter of Lord Carnegie (later 1st Earl of Southesk; see no. 70), on 10 November, but the portrait was not delivered to Kinnaird Castle, where the couple were living, until 2 December: this suggests that Jamesone worked on the portrait after the original sitting or sittings.

The portrait is, rather unusually, on panel and is in much better condition than many of Jamesone's surviving works. The pigment is now rather transparent in places but even originally parts of the ground must have been left exposed in order to act as half-tones. In many ways it is close to de Colone (cf. no. 51) but there is a sense of vision which quite transcends that painter's concern with surface realism. It is painted with breadth, directness, and also extreme delicacy, means which create an image perfectly in accord with the known qualities of the sitter, courageous, intelligent, and imaginative.

Colour illustration

Detail from 62

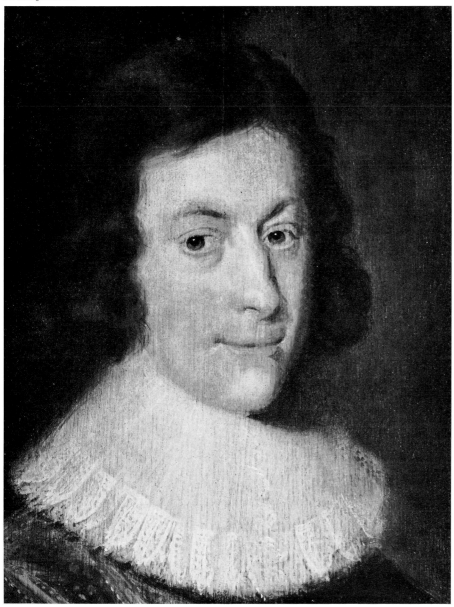

Charles I. This was a colourful event, classical though also a trifle bucolic, placing great emphasis on the antiquity of the kingship, and stage-managed by William Drummond of Hawthornden. The king entered through the West Port where, before a painted view of Edinburgh, he was presented with the keys of the city by the nymph Edina. At the Overbow was the first triumphal arch where Caledonia made a speech on the length of the king's ancestry. A second triumphal arch stood at the Tolbooth 'whereon were painted the Portraits of the Hundred and nine Kings of Scotland'; from this Mercury led Fergus, first king of Scotland, who welcomed the king (see William Maitland, *The History of Edinburgh*, 1753, pp. 64–6).

It is not clear if Jamesone provided all 109 portraits: it may be that his only were preserved but there has never been any record of the remainder. The sources for the programme must have been books like John Jonston's *Inscriptiones Historicae Regum Scotorum* (see no. 73) and Hector Boece's *A Brief Chronicle of all the Kings of Scotland* (an edition was produced in Aberdeen in 1623). The sources of most of Jamesone's images are more difficult to establish though there were precedents for some (see no. 64 below; see also nos. 2–6). Generally, before they were battered (and ultimately dispersed), they were brightly coloured and nearer in some ways to the decorative tradition than to easel-paintings. Though their aesthetic interest is slight, they are of historical interest as fragments of public, political happenings which, though purely ephemeral, were common in the sixteenth and seventeenth centuries. At a far more sophisticated level it was a genre not spurned by someone of the standing of Rubens.

The present picture, now that it has been cleaned and restored, gives a clear idea of the original appearance of the series: high-keyed, colourful, rather vapid as images but lively and spontaneous.

Two Portraits from a Historical Series of Scottish Monarchs

63 Robert Bruce (1274–1329)

Canvas: $27\frac{1}{4} \times 23\frac{1}{2}$ (69.2 × 59.7)
Signed lower left: *Jamesone / F.*; inscribed top right: ROBERTVS BRVSIVS. *Anno.1306*.

Provenance: untraced between 1633 and *c.* 1720, when it entered the Lothian collection at Newbattle Abbey; sold at Dowell's, Edinburgh, 2 July 1971, lot 176.

Literature: Thomson (cited above), pp. 26–7, 53–4, 65–7, and no. 48.

Private Collection

This imaginary portrait is one of a series of twenty-six (or twenty-six surviving) portraits of Scottish monarchs which the Council of Edinburgh commissioned from Jamesone in the summer of 1633 as decorations for the triumphal entry of

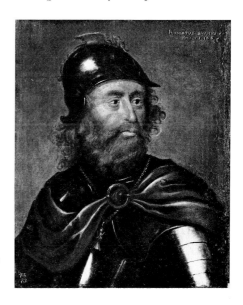

64 James III (1457–1488)

Canvas: 27½ × 23½ (69.8 × 59.7)
Inscribed top right: IACOBVS 3 ./*Anno 1488.*

Provenance: untraced between 1633 and *c.* 1720, when it entered the Lothian collection at Newbattle Abbey.

Exhibition: London, New Gallery, *Royal House of Stuart*, 1889, no. 5.

Literature: Thomson (cited above), no. 42.

Lent by the Marquess of Lothian

One of the series described above. It is clearly a more 'finished', more 'historical' image than no. 63. The pattern has a remarkably long and relatively unchang-

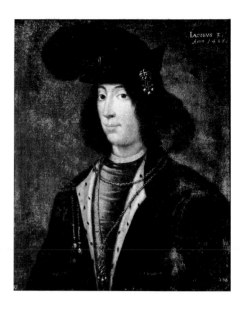

ing history. The earliest portrait of James III is that in the altarpiece painted by Hugo van der Goes about 1478 for the church of the Holy Trinity in Edinburgh (see C. Thompson and L. Campbell, *Hugo van der Goes and the Trinity Panels in Edinburgh*, 1974): it is coarse and clumsy and clearly not by van der Goes himself but whenever and by whomever it was inserted it is clearly related to the superb coin, the heavy groat of *c.* 1485 (see no. 74). What is basically the same image reappears as one of the series of panels of the first five Jameses of about 1570 (see no. 4), as one of the illuminations in the Seton Armorial of 1591 (see no. 24), and as one of the engravings in Jonston's *Inscriptiones* (see no. 73). Whatever the immediate source of Jamesone's image, it has a full-blooded quality which is found only in the coin.

Portrait from a Historical Series of the Ladies of Glenorchy

65 Lady Katherine Ruthven (d. 1588)

Canvas: 33 × 27½ (83.8 × 69.8)
Inscribed around the painted oval:
DOMINᴬ KATHERINA RVTHVEN FILIA WILLIELMI DOMINI RVTHVEN EIVS SPONSA ANNO DOM̄ M. D. LXXXIII

Provenance: family ownership since painted.

Literature: John Pinkerton, *The Scottish Gallery*, 1799, p. 33; *The Literary Correspondence of John Pinkerton*, 1830, vol. i, p. 136; *The Black Book of Taymouth*, edited Cosmo Innes, 1855, p. vii; Bulloch (cited above), no. 106; Thomson (cited above), pp. 70, 91, and no. 78–(6).

Lent by Armorer, Countess of Breadalbane

This is the last in a series of eight 'fancy' or imaginary portraits which Jamesone painted for Sir Colin Campbell of Glenorchy in 1635. Two years before this, probably influenced by the public display of portraits during Charles I's visit to Edinburgh, Campbell of Glenorchy had commissioned an unidentified painter, who is described as being German, to paint a series of eight portraits of his male ancestors. Jamesone was called upon to provide the female pendants. The genealogical programme was taken from the manuscript family chronicle known as the Black Book of Taymouth, which contains a series of illuminations of the male ancestors (no. 58): these, with one exception which may be the work of Jamesone, appear to have been painted by the so-called 'Germane painter'. The date on the present portrait is the date of death of the subject's spouse, Sir Colin Campbell, 6th laird of Glenorchy.
 The portrait should be imagined, therefore, not as an isolated unit, but as part of an ensemble of sixteen such pictures grouped closely together in some kind of

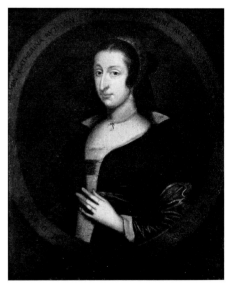

symmetrical arrangement in the 'chalmer of deas' in Glenorchy's house of Balloch. Stylistically, Jamesone's series falls somewhere between his Edinburgh monarchs and his portraits from life. They are a little less heraldic than the monarchs: though colour is used decoratively, it is absorbed into a scheme of light and shade which creates an image with some substance. The present painting seems rather less idealized than its companions and it may be that it has been based on some already existing portrait.

66 Genealogy of the House of Glenorchy, 1635

Canvas: $92\frac{3}{4} \times 59$ (235.5 × 149.8)
Inscribed on *cartellino* bottom right:
The Genealogie of the / hous of
Glenvrquhie/ Quhairof is descendit /
sindrie nobill and / worthie houses /
1635; signed bottom right of *cartellino*:
G Jamesone faciebat

Provenance: family ownership until sold
1969.

Literature: Bulloch (cited above), no. 48;
Thomson (cited above), pp. 30, 31, 71–2,
and no. 93.

Scottish National Portrait Gallery

The Black Book of Taymouth (see no. 58)
records that during 1635 Sir Colin
Campbell of Glenorchy paid Jamesone a
total of £440 for twenty-two paintings:
three 'fancy' portraits of kings (including
Charles I), ten queens (including
Henrietta Maria), eight ladies of
Glenorchy (see no. 65 above), and Sir
Colin's own portrait. Rather oddly, there
is no recorded payment for the startling
object, the vast family-tree, nor is there
any obvious reference to it in the few
surviving letters between Jamesone and
Sir Colin's agent in Edinburgh, Archibald
Campbell. It is, however, listed in an
inventory of Sir Colin's goods made up
on his death in September 1640.

It certainly represents the most
ambitious aspect of Glenorchy's use of
the visual arts during the years 1633–1637
to codify his ancestry and family connec-
tions. Aesthetically, it is something of a
regression on Jamesone's part, for it has
more in common with the art of the
heraldic painter. It is a later variant on
the Tree of Jesse theme and there are a
number of English precedents, but not on
this scale or with this level of inventive-
ness. The strange cherry tree, festooned
with 150 discs containing genealogical
information, has a curious life of its own,
slightly windblown—a trace of Jamesone's
capacity to suggest atmosphere.

At the base of the tree reclines the
figure of Duncan Campbell of Lochow,
founder of the family. On the offshoot is
the Earl of Argyll, while on the trunk
itself are the eight lairds of Glenorchy,
each inscribed with his name and the
number of years he 'lived laird'. With
the exception of Sir Colin (second head
from the top), these images are not
related to either the illuminations in the
Black Book or the German painter's set
of lairds. Sir Colin himself appears to be
painted from life and the head is closely
related to that in the Black Book, which
illumination may, therefore, be the work
of Jamesone. Below this, the portrait of
the 7th laird, Sir Duncan, appears to be
derived from the three-quarter length
painted in 1619 (no. 32). The indistinct
portrait of a young man at the top may
be damaged and altered or it may be

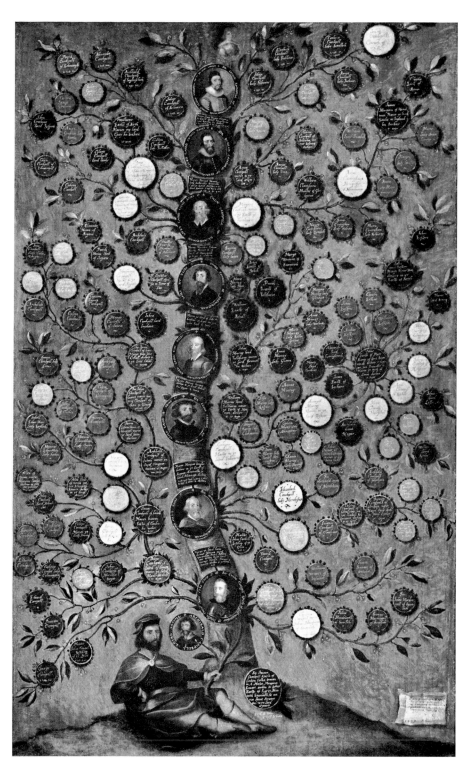

incomplete. It ought to represent Sir
Colin's heir, his fifty-six-year-old brother
Robert but it may be that the latter's son
John, about twenty-eight in 1635, was
thought more likely to succeed.

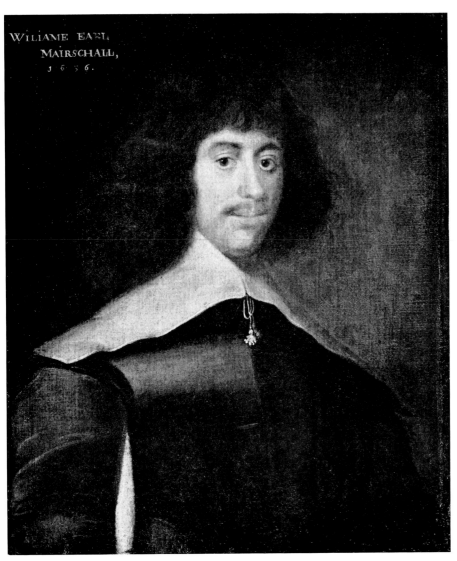

WILIAME EARL
MAIRSCHALL,
1 6 3 6.

ance of many of his portraits. The ground is a chalk-size gesso which is not oil-bound though it is tinted with yellow ochre; however, the binding medium of the pigment is oil-based and there is no indication of gum or proteinaceous material being used, as has often been suggested. The paint itself must even originally have been lacking in body except in the highlights: virtually uncovered ground does duty for the middle tones. Consequently, even slight rubbing has removed pigment and washing has disturbed the ground which, not being oil-bound, was easily penetrated by water.

William Keith was the eldest son of Mary Erskine, Countess Marischal, whom Jamesone had painted ten years earlier (no. 60). His brother George was godfather to Jamesone's son George on 31 January 1633. The brash precipitancy of the youth, about to be embroiled as a leading figure in the coming troubles, seems embodied with some truth in Jamesone's image. In 1639 Jamesone, probably because of his degree of intimacy with his family, was part of an embassy sent by Aberdeen to discover the aims of Marischal, Montrose, and others, who stood outside Aberdeen with a covenanting army.

67 William Keith, 7th Earl Marischal (1614–1661)

Canvas: $25\frac{1}{2} \times 22\frac{1}{4}$ (64.8 × 56.5)
Inscribed top left: WILIAME EARL / MAIRSCHALL, / *1636*.

Provenance: in Campbell of Glenorchy (later Earls and Marquesses of Breadalbane) possession until 1925, having been latterly with Lady Elizabeth Pringle, R. Baillie Hamilton, and Lieut.-Col. Thomas Breadalbane Morgan-Grenville-Gavin at Langton House, Duns.

Literature: *Correspondence of John Pinkerton* (cited above), vol. i, p. 135; Bulloch (cited above), no. 102; Thomson (cited above), pp. 53–4, 70–1, and no. 94.

Scottish National Portrait Gallery

One of a series of probably eleven portraits of contemporaries with whom Sir Colin Campbell believed himself to be connected (see also nos. 68–9 below). They are probably the pictures referred to by Jamesone in a letter of 13 October

1635 to Sir Colin: 'and as for the picturis quhilk [which] I am yeit to make I shall do all diligens to gett theam with the first occasione, bot it will be in Janvarij befoir I can begin theam, except that I have the occasione to meit with the pairties in the North, quhair [where] I mynd to stay for tuo monethes . . .' In another letter, sent from Edinburgh on 23 June 1636, which seems to concern the same group, Jamesone mentions sixteen intended pictures: these may or may not have been completed. Some were done from life, while others were versions of portraits Jamesone had already painted as his further remarks make clear: 'all that are heir in town neidis onlie yowr worships letter to theam to causs theam sitt, and for theam quhois [whose] picturis I hawe alreadie, I shall double theam, or then giwe yowr worship the principall.'

Recent cleaning has revealed a spontaneity which suggests that this particular portrait was done from life. It has also undergone a technical investigation to try to determine if Jamesone used any unorthodox methods which might help to explain the thin and rather rubbed appear-

68 William Graham, 7th Earl of Menteith and 1st Earl of Airth (1589–1661)

Canvas: $42\frac{1}{8} \times 50\frac{5}{8}$ (107 × 128.6), including no. 69 below
Later inscription at top: WILLIAM ERLE OF ÆIRTH / *1637*

Provenance: in Campbell of Glenorchy (later Earls and Marquesses of Breadalbane) possession until sold at Christie's, 23 March 1956, lot 169; sold there again, 1 June 1956, lot 88.

Literature: *Correspondence of John Pinkerton* (cited above), vol. i, p. 135; Bulloch (cited above), no. 42; Thomson (cited above), pp. 43, 70–1, and no. 96.

Scottish National Portrait Gallery

Part of the same series of contemporary noblemen as no. 67 above. The sitter was Sir Colin Campbell's cousin and the portrait is presumably one of those which by 23 June 1636 (see above) had still to be painted. The portrait has a

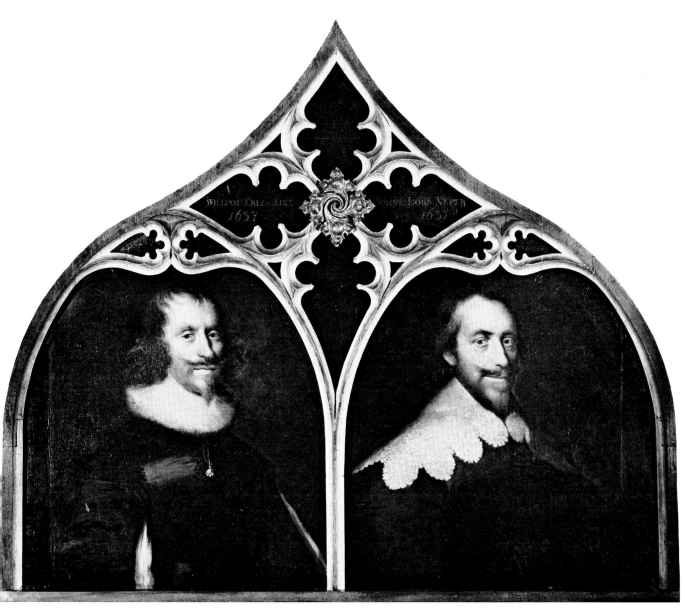

peculiar brooding power and in its general compactness and assurance is reminiscent of Miereveld.

Airth, though on bad terms with Charles I because of his claims to the earldom of Strathern, was a firm member of the anti-covenanting party.

At some time in the early nineteenth century the picture was relined in conjunction with no. 69 on a single ogee-shaped canvas. This treatment was meted out to other Breadalbane portraits to fit them into the neo-gothic schemes at Taymouth Castle.

69 Archibald Napier, 1st Baron Napier (1576–1645)

Canvas: $42\frac{1}{8} \times 50\frac{5}{8}$ (107 × 128.6), including no. 68 above
Later inscription at top: IOHNE LORD NEPER / *1637*; signed bottom right: *Iame* [remainder cut away]

Provenance: as for no. 68 above.

Literature: *Correspondence of John Pinkerton* (cited above), vol. i, p. 135; *The Black Book of Taymouth* (cited above), p. viii; Bulloch (cited above), no. 43; Thomson (cited above), no. 97.

Scottish National Portrait Gallery

Another of the series of noblemen connected to Campbell of Glenorchy. Napier was a descendant of Sir Duncan Campbell, 4th laird of Glenorchy. The error in the inscription (John instead of Archibald) may stem from the time when the picture

was relined and paired with no. 68 above, perhaps from a misreading of a damaged original inscription. In any case, the confusion is presumably with the subject's better known father, John Napier, the inventor of logarithms (no. 31).

The picture appears to be derived from an earlier portrait of the subject still in family possession: the costume, however, has been updated.

Besides the three pictures exhibited, the other subjects who are known to have been part of the series, though not all surviving, were as follows: Thomas Hamilton, 3rd Earl of Haddington (1636); Anne Cunningham, Marchioness of Hamilton (probably 1636: lost); James Hamilton, 1st Duke of Hamilton (probably 1636: lost); John Leslie, 1st Duke of Rothes (probably 1636: lost); John Erskine, 3rd Earl of Mar (probably 1636: lost); John Lyon, 2nd Earl of Kinghorne (1637); John Campbell, 1st Earl of Loudoun (1637: lost); James Erskine, 6th Earl of Buchan (given to the Earl of Buchan about 1780: destroyed 1955).

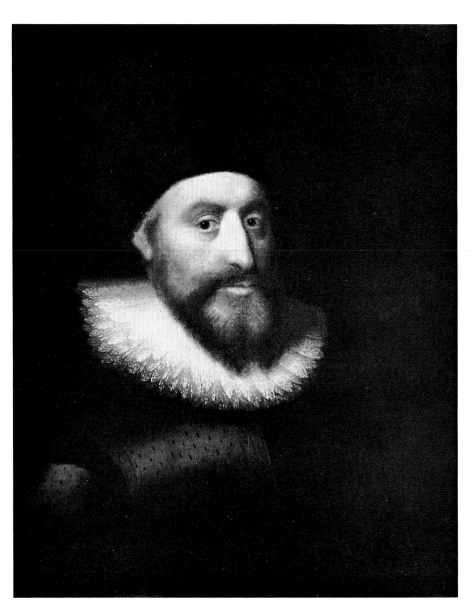

70 David Carnegie, 1st Earl of Southesk (c. 1575–1658)

Canvas: 26¾ × 23¾ (68 × 60.3)

Provenance: family ownership since painted.

Literature: William Fraser, *History of the Carnegies*, 1867, vol. ii, p. 551; James L. Caw (cited above), p. 11; Thomson (cited above), p. 75, and no. 116.

Exhibition: Aberdeen, *Archaeological Exhibition*, 1859, no. 137.

Lent by the Earl of Southesk

Jamesone painted the subject's brother, Sir Robert Carnegie of Dunnichen, in 1629, probably about the same time that he painted the young Montrose (no. 62). The present portrait was almost certainly done in 1637 (it was apparently once so inscribed), the same year in which Jamesone painted the two other brothers, John Carnegie, 1st Earl of Ethie and Northesk, and Sir Alexander Carnegie of Balnamoon. These four portraits hang together at Kinnaird and were presumably put together consciously as a small family gallery when they were painted.

The present portrait is now the finest of the series, though the *Sir Alexander Carnegie* must originally have had many of the same qualities. The picture is seen in terms of quite broad light and shade, the energy and power of the finely constructed head set off by the delicacy of the painting of the ruff. It has a combination of insight, precision of drawing, and breadth of handling which place it near the peak of Jamesone's achievement.

By the king's special request, David Carnegie accompanied Anne of Denmark and the royal children to London after the king's accession: for this he was knighted. He was created Lord Carnegie in 1616 and the following year was visited by the king on his only visit to Scotland. In 1633 he was raised to the earldom of Southesk on Charles I's coronation at Holyroodhouse.

71 The Family of Thomas Hamilton, 2nd Earl of Haddington (1600–1640)

Canvas: 43½ × 52 (110.5 × 132.1)
Later inscriptions below the four principal figures and a false 'signature' bottom right.

Provenance: family ownership since painted.

Exhibition: Edinburgh, *Loan Exhibition of Old Masters*, 1883, no. 101.

Literature: Bulloch (cited above), no. 97; Sir William Fraser, *Memorials of the Earls of Haddington*, 1889, vol. i, p. 375; Waterhouse (cited above), p. 41; Thomson (cited above), pp. 72–3, and no. 130.

Lent by the Earl of Haddington

This painting is probably retrospective. The future earl's wife, Catherine Erskine, Lady Binning (sister of no. 60) had died in 1635 and the picture seems later than that date. It may celebrate the earl's succession to the title in 1637. His figure is taken from a Van Dyck studio portrait still at Tyninghame, but the transition has not been a happy one. Lady Binning's head may be based on a miniature by John Hoskins, also at Tyninghame, but reversed. The head of the future 3rd Earl is derived from another portrait by Jamesone in the same collection but done originally for Campbell of Glenorchy in 1636 (see notes to no. 67). The future 4th Earl is also closely related to a portrait by Jamesone (cf. no. 75).

This is the earliest true Scottish conversation piece. Jamesone had attempted to open up the picture space in two full-length portraits of the Earl and Countess of Rothes in the 1620s (Thomson, nos. 6 and 7) where the subjects are shown in interiors. The attempt, however, had been vitiated by the somewhat ill-conceived drawing. In the present case the setting is not unsuccessful, and the atmospheric effects are convincing, but the drawing of the protagonists remains awkward and naïve. Nevertheless, the picture has considerable charm, the unusually rich colour is successfully integrated, and there are passages of quite accomplished painting, for example, the head of the dwarf.

The conception may derive from an immensely more sophisticated painting by Mytens at Hampton Court, *Charles I and*

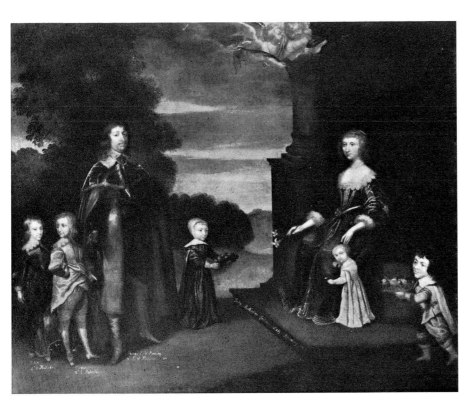

Henrietta Maria departing for the Chase, of *c.* 1630–1632, which also consists of two halves, a dais closed in by pillars and an open landscape. Haddington's improbable dwarf and the angels also seem derived from that picture.

Haddington was fatally injured in the explosion at Dunglass Castle in 1640.

72 Self-portrait, in a Room hung with Pictures

Canvas: 27 × 33 (68.5 × 83.8)

Provenance: untraced before 1781, when in possession of the Earl of Findlater; by descent thereafter.

Literature: Horace Walpole, *Additional Lives . . .*, 1768, p. 3; *Correspondence of John Pinkerton* (cited above), vol. ii, pp. 21–2, 90, 149–50; Walter Thom, *The History of Aberdeen*, 1811, p. 202; Bulloch (as cited), no. 169; Thomson (as cited), pp. 74–5, and no. 112.

Exhibitions: Aberdeen, *Archaeological Exhibition*, 1859, no. 122; Edinburgh, *Loan Exhibition of Old Masters*, 1883, no. 2; Glasgow, *International Exhibition*, 1901, no. 992; Glasgow, *Scottish Exhibition*, 1911, no. 26; Royal Academy, *Scottish Art*, 1939, no. 3; Glasgow, *Scottish Painting*, 1961, no. 11.

Lent by the Earl of Seafield

There are four known self-portraits of Jamesone, all of about 1637–1640: one in Aberdeen (Art Gallery) in which he holds a miniature which seems to be derived from Rubens's self-portraits of the mid-1620s; a small portrait in Edinburgh (Scottish National Portrait Gallery) of the same type, but largely repainted by John Alexander in 1763; a portrait at Fyvie which introduces the painter's wife and one of their children, though the painter's figure remains the same basic type; and the present painting where the type is once again the same but where the figure is placed in an elaborate setting.

The painting has suffered considerable damage and must be read with a good deal of discretion. Areas of canvas have been replaced, particularly most of the dark area of the painter's body. It has, nevertheless, been an ambitiously conceived picture and suggests that Jamesone had a very distinct conception of his own role in the community—painter, with such a near-monopoly that he was seen as a new kind of phenomenon, man of property, and man of affairs, as he undoubtedly was, though in a minor way, in the shifting politics of the time—rather, indeed, like a Scottish Rubens. Behind the conventional symbols of mortality, the skull and the hour-glass, hang a group of the artist's works, not all of them portraits. By far the most interesting of these is the mythology which is evidently a Chastisement of Cupid of a northern mannerist sort (a painting of this subject dated before 1632 and attributed to Simon de Vos in Berlin-Dahlem contains a group of very similarly arranged figures).

The early provenance of the picture provides ground for speculation. The earls of Findlater were direct descendants of Sir John and Sir James Grant of Freuchie, both of whom patronized Jamesone's master John Anderson, Sir John and Anderson being on surprisingly intimate terms (see Thomson, p. 52). Could Jamesone's self-portrait, which is hardly likely to have been commissioned, have found its way into the possession of Anderson, probably a relative and who outlived him, and thence to the Grants?

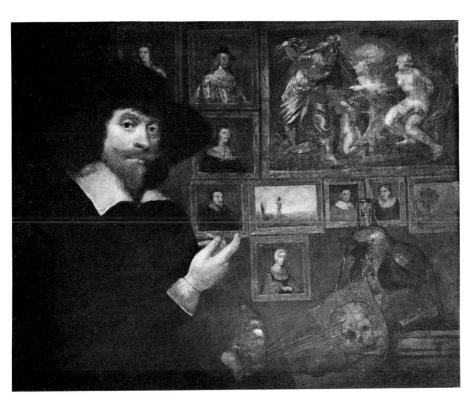

70

Related Book

73 *Inscriptiones Historicae Regum Scotorum, continuata annorum serie a Fergusio primo Regni Conditore ad nostra tempora* by **John Jonston**

Amsterdam, 1602 (for Andrew Hart, Edinburgh)

Literature: A. M. Hind, *Engraving in England . . .*, Part II, 1955, pp. 49–50.

Lent by the National Library of Scotland

John Jonston, or Johnston (before 1570–1611), studied at King's College, Aberdeen, followed by some years at continental universities; he became a friend of Lipsius. He was made professor of divinity at St Andrews about 1593, perhaps through the influence of Andrew Melville, a life-long friend.

The *Inscriptiones* consists of a series of epigrammatic addresses to the Scottish kings from Fergus I to James VI, to whom the book is dedicated. At the end are ten engraved plates of Roberts II–III, Jameses I–VI, Mary, and Anne of Denmark, presumably done in Amsterdam.

The book is open at the plate of James III. Jamesone must have used this book as the programme for his series of monarchs (see nos. 63 and 64). The portrait of James III is part of the chain of connected images stretching from the Trinity altarpiece, through the groat of *c.* 1485, to Jamesone's portrait of 1633 (no. 63). The other Jameses relate to the sixteenth-century series of monarchs (nos. 2–6).

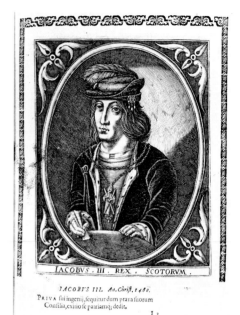

Related Coin

74 **Three-quarter face groat of James III (1457–1488)**

Diameter 1 (2.6); value 14 pence; date *c.* 1485

Literature: Edward Burns, *The Coinage of Scotland*, 1887, vol. ii, p. 137 (type 46/43); J. H. Stewart, *The Scottish Coinage*, 1967, pp. 66–7.

Lent by the National Museum of Antiquities of Scotland

The portrait on the James III groat is a totally inexplicable and totally isolated manifestation of the Renaissance conception of portraiture in Scottish art. Its breathtaking freshness, fulness as an image, and vivid immediacy as a portrait, are entirely in the Italian quattrocento manner, and even in that context the three-quarter face on coins and medals was unusual. It is a brilliant and unique landmark.

It later became the basis of the standard image of James III, turning up in a primitive, increasingly coarsened form in a variety of places: in the sixteenth-century portrait series of Scottish monarchs (no. 4), in the Seton Armorial (no. 24), and in Jonston's en-

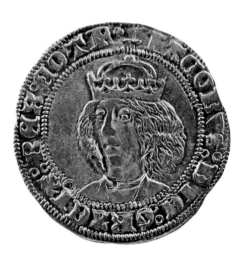

graving (no. 73). Jamesone breathed new life into the image which he included in his series of monarchs painted to entertain Charles I in 1633 (no. 64). So close is the painting to the coin in detail and expression that it seems certain he must have worked directly from it.

Michael Wright

1617-1700

The earliest certain fact about Michael Wright is his apprenticeship to George Jamesone in Edinburgh on 6 April 1636, for a period of five years.[1] He may have come north because his father, James Wright, tailor and citizen of London, was a Scot—contact could have been established on Jamesone's visit to London in the late summer of 1633. According to Vertue's informant, Wright was born in Scotland and came to London when he was about sixteen or seventeen years old.[2] This is a surprisingly neat reversal of what appears more likely to be the case, that Wright is identical to the 'Mighelle s[on] of James Wryghtt' who was baptized in St Bride's, Fleet Street, on 25 May 1617,[3] and was thus eighteen years old when he came to Edinburgh. Another source, however, quoted by Thomas Hearne, says that Wright was born in the parish of St Andrews in Holborn; and that in his youth he was converted to catholicism by a Scot in London and taken to Scotland and thence to Rome.[4] This seems improbable, though Wright appears to have become a catholic at some stage in his life.

No certain works are known from the period of Wright's apprenticeship, which would normally have ended in 1641. Given his accomplishment, it is not inconceivable that he produced portraits within the orbit of Jamesone's patronage. Records for the years prior to 1648 are, however, non-existent; in that year he became a member of the Academy of St Luke in Rome and a list of members gives his name as 'Michele Rita *inglese*'—the form may not have been used any more exactly than it is today but some eighteenth-century painters are specifically called 'scozzese'.[5] Here his horizons widened to an enormous extent, given his earlier training: among the other foreign painters in the Academy were Claude Melan, Poussin, Sandrart, and Velazquez.

Wright appears to have given over much of his time in Rome to antiquarian pursuits which prepared him, according to Hearne's dubious account, for the post of antiquary to the Archduke Leopold William.[6] His earliest English work is a small, probably posthumous, portrait of Elizabeth Cromwell, Mrs Claypole, which is dated 1658.[7] He was certainly in England by 1659 when he dated one of his finest portraits, that of Colonel John Russell.[8] In the same year the diarist Evelyn refers to him as 'the famous Painter Mr Write'.[9] The portraits produced in these years were probably his finest, their mood and solidity reminiscent of Dobson, and often far more individualized than Lely; they are warm and sympathetic, qualities which Hearne records of Wright: 'free and open . . . of great plainness and simplicity, and of a very easy temper'.[10]

In these years Wright inexplicably adopted the additional Christian name of John: he also styled himself 'pictor regius', presumably on the strength of the magnificent state portrait of Charles II.[11] A version of this, apparently adapted to represent James II, accompanied Wright and the Earl of Castlemaine on the latter's embassy to the Pope in 1686. Wright published an account of the embassy in Italian and an English version came out in 1688.[12] During these years Kneller gained ascendancy as Lely's successor and Wright's last years were unsuccessful and impoverished. According to Hearne he was buried at St Martin's in the Fields in the 1680s[13] but Vertue, much more credibly, states that he died at James Street, Covent Garden, in 1700.[14]

REFERENCES (1) Printed in full in D. Thomson, *The Life and Art of George Jamesone*, 1974, p. 135. (2) 'Vertue Notebooks', *Walpole Society*, vol. xviii (I), 1930, p. 44. (3) Ellis Waterhouse, *Painting in Britain 1530–1790*, 1962, p. 66: this contains by far the fullest and best account of Wright's life and career. (4) *Reliquiae Hearnianae: the Remains of Thomas Hearne*, edited Philip Bliss, 1857, vol. i, pp. 343–4. (5) Melchior

Missirini, *Memorie per servire alla storia della Romana Accademia di S Luca*, 1823, p. 472. (6) *Reliquiae Hearnianae* (as cited), pp. 344–5. (7) National Portrait Gallery, no. 952. (8) Ham House. (9) *The Diary of John Evelyn*, edited E. S. de Beer, 1955, vol. iii, p. 228 (under 5 April). (10) *Reliquiae Hearnianae* (as cited), p. 346. (11) See Oliver Millar, *The Tudor, Stuart and Early Georgian Pictures in the Collection of Her Majesty The Queen*, 1963, Text, no. 285. (12) *An Account of His Excellence Roger Earl of Castlemaine's Embassy from His Sacred Majesty James the IId . . . to His Holiness Innocent XI*, by Mr Michael Wright: see the engraving of a banquet by Lenardi at p. 68. (13) *Reliquiae Hearnianae* (as cited), p. 346. (14) 'Vertue Notebooks' (as cited), p. 117, and vol. xx (II), p. 138.

See also the following: W. J. Smith, 'Letters from Michael Wright', *The Burlington Magazine*, vol. xcv, 1953, pp. 233–6; Dennis Farr, 'A Rediscovered John Michael Wright Signature', *The Burlington Magazine*, vol. ciii, 1961, pp. 68–71.

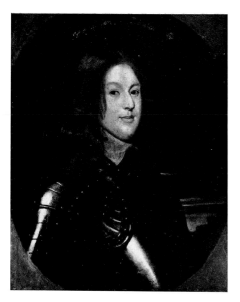

75 John Hamilton, 4th Earl of Haddington (1626–1669)

Canvas: 28 × 23 (71.1 × 58.4)
Later inscription at top: *John 4: Earl of Hadinton*

Provenance: family ownership since painted.

Literature: Thomson (cited above), p. 73.

Lent by the Earl of Haddington

Attributed. Costume and the apparent age of the sitter must date this painting about 1640 and thus within the period of Michael Wright's apprenticeship in Scotland. The paint has a rather dry quality and that sensitivity to tonal nuance which are characteristic of the mature Wright. The ovoid head and, more particularly, the rather large, lemon-shaped eyes are features of the drawing which also connect with Wright, while

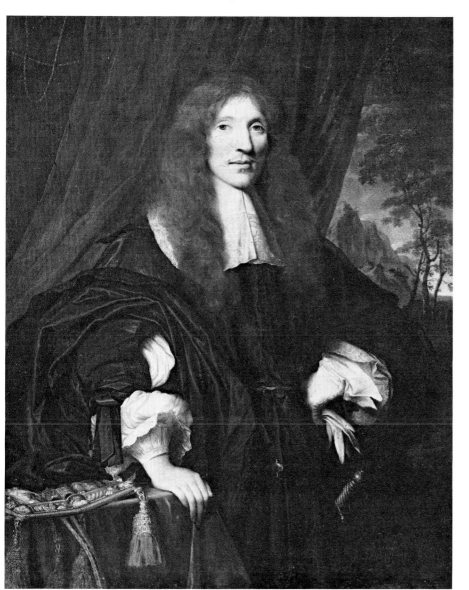

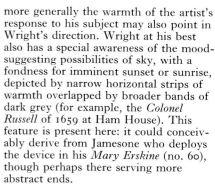

more generally the warmth of the artist's response to his subject may also point in Wright's direction. Wright at his best also has a special awareness of the mood-suggesting possibilities of sky, with a fondness for imminent sunset or sunrise, depicted by narrow horizontal strips of warmth overlapped by broader bands of dark grey (for example, the *Colonel Russell* of 1659 at Ham House). This feature is present here: it could conceivably derive from Jamesone who deploys the device in his *Mary Erskine* (no. 60), though perhaps there serving more abstract ends.

There is a painting by Jamesone of the same sitter, perhaps slightly earlier, at Tyninghame, one of his elder brother the 3rd Earl and, of course, the family piece of the 2nd Earl and his family (Thomson, nos. 129, 95, and 130). This patronage suggests another link with Jamesone.

The sitter suffered much from ill-health and took little active part in affairs, particularly military ones.

76 William Cunningham, 8th Earl of Glencairn (*c.* 1610–1664)

Canvas: 50 × 40¼ (127 × 102.2)

Provenance: by descent to Elizabeth, Countess of Glencairn (d. 1801), at Coates House; entered the collection of the Earls of Fife in the nineteenth century; sold by the 1st Duke of Fife at Christie's, 7 June 1907, lot 16.

Exhibition: Edinburgh, *Loan Exhibition*, 1883, no. 97.

Literature: John Pinkerton, *The Scottish Gallery*, 1799, p. 111.

Scottish National Portrait Gallery

Though undocumented and unsigned, the attribution cannot be questioned. Besides the sensitive use of an area of landscape to create mood, this portrait shows Wright's passion for the textures and vagaries of elaborate costume. This is often particularly noticeable in the gathering of materials at the wrists. Here the intricate patterns in that area have a piercing clarity and are focal points for the larger volumes which swirl round them in widening concentric circles. These near obsessional forms are balanced, again in a way typical of Wright, by the measured calm of the face.

The portrait was presumably painted in London late in 1660 when Glencairn was promised the Lord Chancellorship; he is shown with the insignia of that office by his right hand.

77 George Vernon (1635–1702)

Canvas (oval): 27 × 24 (68.6 × 61)

Provenance: family ownership since painted.

Lent by the National Trust, Vernon Collection, Sudbury Hall

The sitter's apparent age must date this portrait no later than 1660. This is one of Wright's most freely handled portraits, the pigment having none of the dry, rather precise character of the *Mrs Claypole* of 1658 (National Portrait Gallery) or, to a lesser extent, of the *Colonel Russell* of 1659 (Ham House). However, the kind of plastic audacity found here was not to be constant.

It is particularly interesting to compare this portrait with Jamesone's *Montrose* painted thirty years earlier (no. 62) and speculate on what traces, if any, of Jamesone's influence remain. Certainly both painters probe form and light quite empirically and with similar spontaneity. The Wright is freer in conception, the Jamesone rather more restricted formally, indicative of their entirely different backgrounds, yet the older painter's draughtsmanship within the features of the face is in many ways more sensitive.

This is one of a series of portraits by Wright of the Vernon family—payments to Wright are recorded in the sitter's accounts for 1659–1660. These include a companion piece of Margaret Onely his wife and two three-quarter lengths of the same subjects. Vernon spent most of his energies on rebuilding, apparently as his own architect, the family seat of Sudbury Hall in Derbyshire (see Christopher Hussey, 'Sudbury Hall, Derbyshire', *Country Life*, vol. lxxvii, 1935, pp. 622–7, 650–6, 682–7).

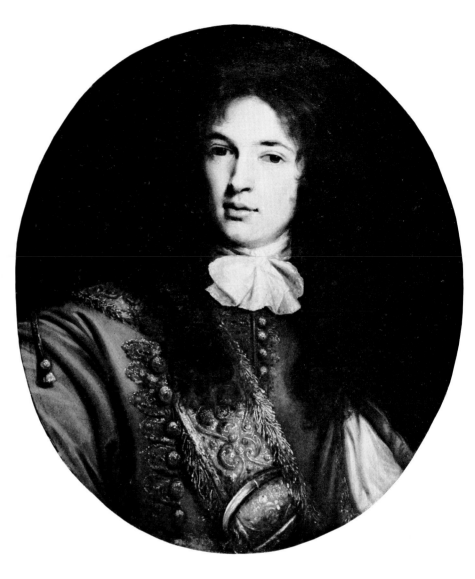

78 Susanna Hamilton, Countess of Cassillis (1632–1694)

Canvas: 28½ × 24 (72.4 × 61)
Signed on right opposite shoulder: *Jo: Mich: Wright p. 1662*

Provenance: presumably in possession of the Dukes of Hamilton until the late seventeenth century; probably entered Tweeddale possession *c.* 1694 when Charles, 3rd Marquess married Susanna, a niece of the subject and daughter of Anne, Duchess of Hamilton; recorded at Pinkie House (Tweeddale) 1739: later at Yester House; at Agnew's 1974.

Literature: Ellis Waterhouse, *Painting in Britain 1530–1790*, 1962, p. 68.

Private Collection

A drier, less plastically adventurous portrait than that of George Vernon (no. 77) but perhaps rather subtler in its reading of character. It is one of Wright's most individualized portraits, a work of formal and interpretive beauty derived from a subject who was clearly far from beautiful. The rather too large lemon-shaped eyes are drawn with Wright's typical rather summary grasp of their particular form.

The portrait was probably painted in London, rather than Scotland. Between August 1662 and February 1664 there are three references in the Hamilton archives to a portrait by Wright of the sitter's sister Anne, Duchess of Hamilton (F 1/297/22, C 1/10072, and C 1/2579). The last of these is a letter from the Duke of Hamilton's agent in London saying that although Wright is full of promises and excuses the picture is no further forward. The present portrait is probably connected with that commission: the sitter, in any case, was at court about the time of the Restoration.

Between 1665 and 1667 (and probably later) she was in attendance to the exiled Henrietta Maria (SRO, GD 248/556/3), perhaps surprising considering her up-bringing as a presbyterian. She married the nineteen-year-old Earl of Cassillis in 1668 or 9 when she herself was thirty-six.

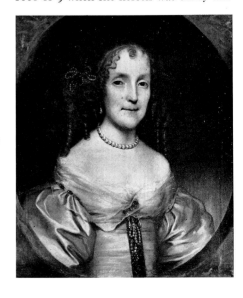

List of Lenders

Her Majesty The Queen 1
Aberdeen, The University of Aberdeen 61
The Executors of the late Marquess of Aberdeen and Temair 33
Sir Ralph Anstruther 54
The Duke of Argyll 48
Armorer, Countess of Breadalbane 27, 58, 65
The Duke of Buccleuch and Queensberry 55
Sir Windham Carmichael-Anstruther 57
Edinburgh, The National Gallery of Scotland 23, 60
Edinburgh, The National Library of Scotland 10, 36, 38, 39, 73
Edinburgh, The National Museum of Antiquities of Scotland 20, 21, 22, 34, 35, 40, 41, 42, 43, 44, 45, 46, 74
Edinburgh, The University of Edinburgh 31
A. Erskine-Murray Esq 56
John Forbes-Sempill Esq 59
Glasgow, The University of Glasgow 37
The Earl of Haddington 71, 75
The Honble H. de B. Lawson Johnston 7
The Kintore Trust 49
The Marquess of Lothian 47, 64
The Earl of Mar and Kellie 51
The Earl of Moray 25
Hugo Morley-Fletcher Esq 52, 53
The National Trust, Sudbury Hall 77
The National Trust for Scotland, Craigievar Castle 59
The National Trust for Scotland, Culzean Castle 13
The National Trust for Scotland, Falkland Palace 12
Sir David Ogilvy 24
Private Collection 63
Private Collection 78
The Earl of Rosebery 26
The Earl of Seafield 72
The Earl of Southesk 62, 70
The Earl of Stair 28, 29, 30

The following items in the exhibition are from the permanent collection of the Scottish National Portrait Gallery: 2, 3, 4, 5, 6, 8, 9, 11, 14, 16, 17, 18, 19, 32, 50, 66, 67, 68, 69, 76

The Rossend Ceiling, the property of the National Museum of Antiquities of Scotland, has been restored and installed in the exhibition by the staff of the Stenhouse Conservation Centre and the Area Works Office of the Department of the Environment, on support material supplied and erected by Carlyle Wishart & Company Ltd.

Printed in Scotland for Her Majesty's Stationery Office
by R. & R. Clark, Ltd., Edinburgh
Dd 394651/3478 K20 8/75